THE
FLOWERS

 OF

WILLIAM MORRIS

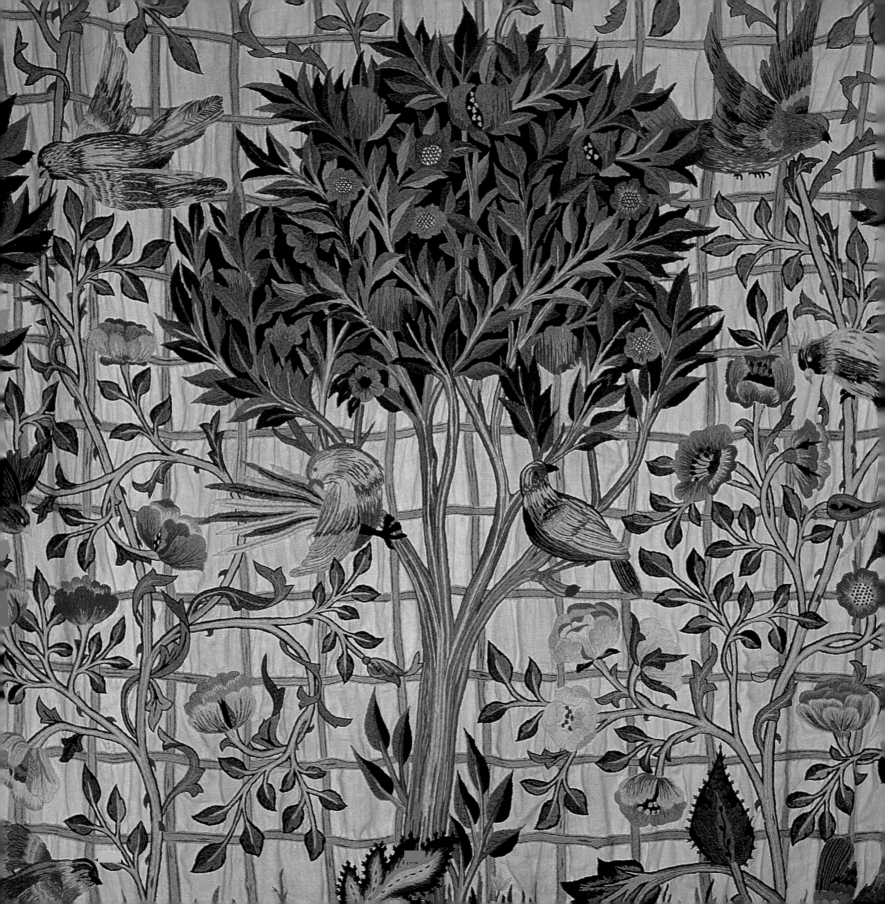

THE
FLOWERS

OF

WILLIAM MORRIS

DEREK W. BAKER

BARN ELMS

First published in 1996 by

Barn Elms Publishing

93 Castelnau, London SW13 9EL

Originated by Create Publishing Services

Printed and bound in Great Britain by

The Bath Press

British Library Cataloguing-in-Publication Data.

A catalogue record for this book is available

from the British Library

ISBN 1 899531 03 3

William Morris Society

The purpose of the William Morris Society is to promote the study of the life, work and influence of this great man. The Society welcomes new members. For details of membership please telephone 0181-741 3735 or write to the William Morris Society, Kelmscott House, 26 Upper Mall, Hammersmith, London, W6 9TA.

Endpapers Marigold, *designed by William Morris for wallpaper and fabric, 1875*

1. Title page *Floral hanging for Morris's seventeenth-century four-poster bed at Kelmscott Manor. The hangings and curtains were embroidered by May Morris and her friends in 1893 using the medieval trellis motif.*

CONTENTS

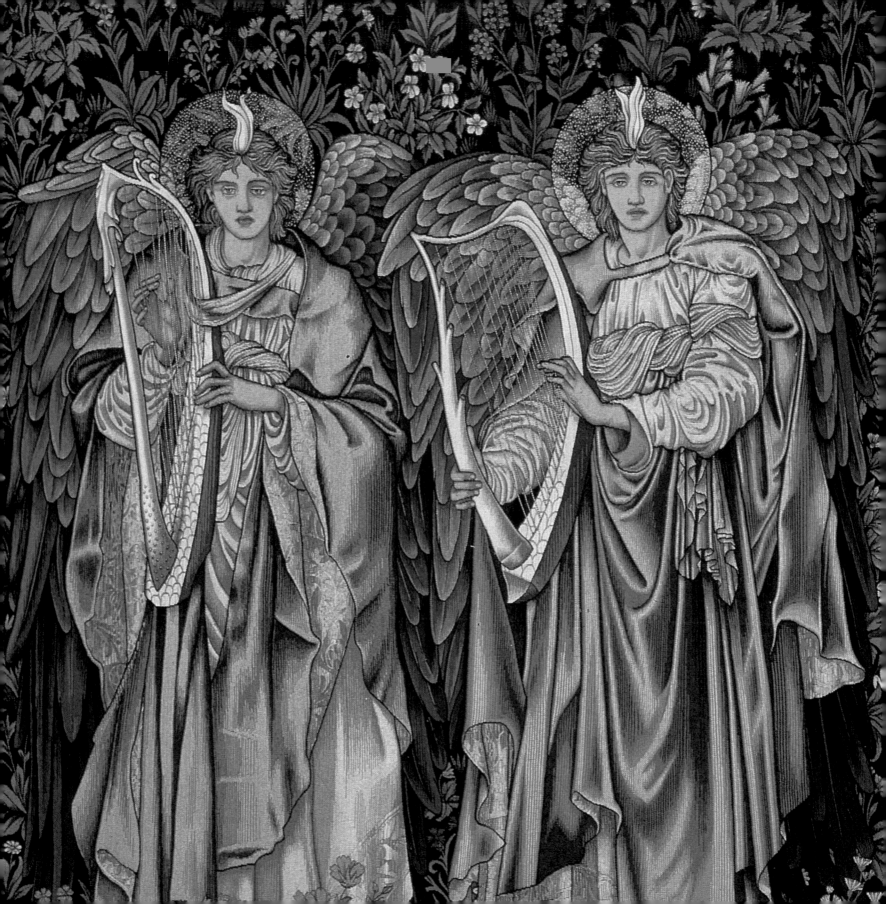

PREFACE

Morris, our sweet and simple Chaucer's child,.... has brought fair flowers to make an earthly paradise. Aymer Vallance, 1897

People throughout the world become interested in William Morris for a wide variety of reasons. My own introduction to Morris was somewhat unusual. A sudden and unexpected interest in botanical illustration and the history of flower painting took me rapidly to art history, early herbals, the history of ornament and the like. Inevitably such a study soon arrived at the nineteenth century and the Victorian obsession with nature, flowers, gardens and botany. Once there the rest of the story is predictable: John Ruskin, the flowers of the pre-Raphaelites and then William Morris and his world.

Today William Morris is probably best known for his floral wallpaper and fabric designs, but surprisingly there has been little written which draws together the flowers and gardens in his life and their contribution to and influence on his designs. Morris was not a hands-on gardener himself (he clipped a hedge or two), but through his writings he continuously reveals his love of nature and his affection for the flowers and gardens which were such an essential part of his life.

Many of the references and quotations in this book are from the first two books written about Morris; Aymer Vallance's *The Life and Art of William Morris* (1897) and the first biography of Morris written by Edward Burne-Jones's son-in-law, John W. Mackail (1899). These are referred to here as Vallance and Mackail respectively. Other references, where not given in the text, are from the writings of May Morris and from the *Collected Letters of William Morris* compiled by Professor Norman Kelvin (two volumes, 1984 and 1987, with a third volume due in 1996).

The author is grateful for the use of the libraries of the William Morris Society and the William Morris Gallery and would like to thank Linda Parry for her encouragement to undertake this work. Thanks are also due to Don Chapman and Clare Miles at Kelmscott Manor, John Brandon-Jones, Roger Colori at the Vestry House Museum, Walthamstow and the staff of the Essex Record Office.

A final point – Morris's spelling was erratic and in the extracts from his letters the text is as it stands in the original.

2. Left *Detail from* Angeli Laudantes *(London, Victoria and Albert Museum), a tapestry designed mainly by Burne-Jones for Morris and Company and woven at the Merton Abbey Works in 1894. It is based on an earlier design for a window in Salisbury Cathedral and uses a millefleurs background, probably set out by Henry Dearle*

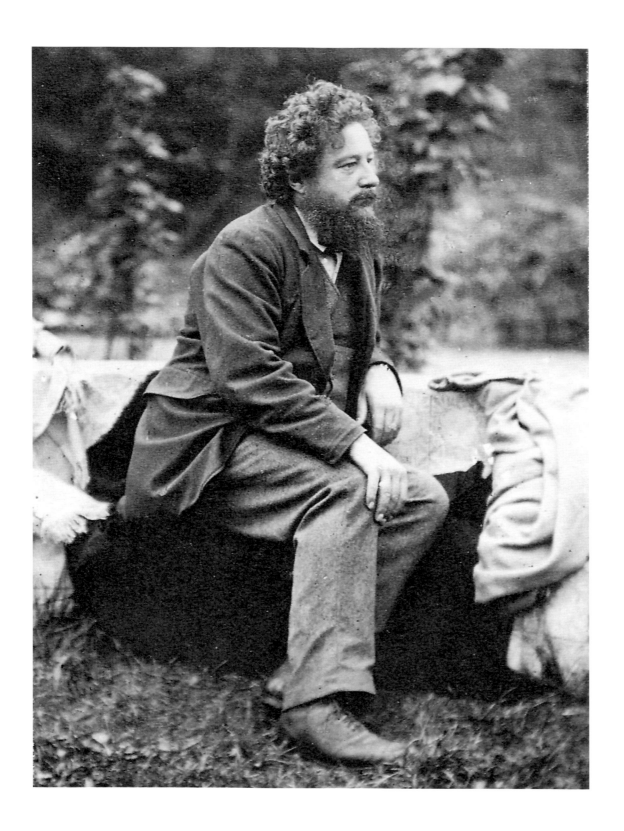

1. AN INTRODUCTION TO WILLIAM MORRIS

William Morris was born in Elm House, Clay Street (now Forest Road), Walthamstow on 24 March 1834. He died at Kelmscott House, his home in Hammersmith (now the headquarters of the William Morris Society) on 3 October 1896 at the age of sixty-two, and is buried, with his wife and two daughters, in the village of Kelmscott near Lechlade not far from Oxford. According to his doctor, he died of 'simply being William Morris and having done more work than most ten men'.

Morris's father was a City man and prospered as a bill broker living in Lombard Street. Later Morris senior made his fortune from copper mining both as a director of a copper mine but also from share dealings in copper. William Morris was to inherit this wealth. In 1833 his parents moved out to Walthamstow and when he was six the family moved again to the spacious Woodford Hall near Epping Forest. After the death of his father in 1847, when William was thirteen, his mother settled in the Water House (now Lloyd Park and the home of the William Morris Gallery) in Clay Street, Walthamstow.

A poet and romantic writer throughout the whole of his life, Morris was also a pattern designer, manufacturer and businessman for about thirty-five years and a passionate, even revolutionary, socialist for twelve years. Linguist, translator of Nordic sagas, calligrapher, designer of fabrics, wallpapers, stained glass, books and furniture, printer of fine books, family man, politican, socialist agitator, conservationist, and acquaintance of many leading Victorians – the range of Morris's skills, interests and talents is astounding and his life and work are studied throughout the world.

The man seems a paradox. He was, on the one hand, very prosperous and a manufacturing entrepreneur throughout most of his life, but then became a passionate socialist, though certainly not a parliamentary man. He was a romantic, a utopian and an energetic humanitarian and it is this side of him that attracts so many to Morris today. The title of a biography by the late E. P. Thompson describes him so well, *Romantic to Revolutionary*. Fiona MacCarthy subtitles her biography of Morris, *A Life for our Time*.

3. **Left** *Photograph by Frederick Hollyer of Morris sitting in the garden at The Grange (the Fulham house of Burne-Jones) in 1874.*

Morris was a graduate of Exeter College, Oxford, and it was there he met his lifelong friend the pre-Raphaelite painter Edward Burne-Jones, the central artist of the second group of pre-Raphaelites following the famous Pre-Raphaelite Brotherhood of 1848 which included John Everett Millais, William Holman Hunt and Dante Gabriel Rossetti. Morris was very influenced by the writings of Thomas Carlyle, Charles Kingsley and especially John Ruskin, the great Victorian sage and art critic, whose writings along with those of Karl Marx led him into the new emerging world of socialism in the mid 1870s.

As a young man Morris loved to be in the boisterous company of his friends and their pre-Raphaelite girl friends. Burne-Jones and his wife Georgiana (Rudyard Kipling's aunt) were his closest friends and after Morris married Jane Burden in 1859 (he was twenty-five and she nineteen) their two families grew up together. Another great friend, the architect Philip Webb, designed and built the Morris's first married home, Red House, and it was there, with his friends, that he founded the manufacturing company which was later to become Morris and Company. Red House is, architecturally, one of this country's most important nineteenth-century houses. Although it is believed Morris's married life was not a great success, for the first few years at Red House in Bexley Heath the family were very happy. But, for reasons still not fully understood, Jane and William moved apart. Red House was sold and they moved to Queen Square in Bloomsbury and lived 'above the shop', so to speak, as Morris built up the firm's business.

Jane throughout most of her life was not well, or at least seemed not to be well. What her medical condition was remains a mystery. Another unresolved part of the Morris story are the alleged infidelities of Jane Morris with the painter Rossetti and the diplomat, and man about town, Wilfrid Scawen Blunt.

In addition to his marriage difficulties Morris's biggest problem was his daughter Jenny's epilepsy, which he feared had been inherited from his side of the family. His younger daughter May was, however, his strength and was to become a socialist, embroiderer, artist and writer in her own right. She recorded much of her father's life and works and became the first president of the Kelmscott Fellowship in 1918 (now the William Morris Society).

The firm, originally Morris, Marshall and Faulkner and later Morris and Company, prospered from 1861 until 1940 and during its existence manufactured wallpapers, decorative textiles, furniture, stained-glass windows, ceramics, tiles, rugs and carpets. It was the most fashionable supplier of the time and was

4. Right *Jane Morris as Proserpine in Dante Gabriel Rossetti's* Proserpine, *1877 (London, Tate Gallery). Proserpine is the mythical goddess of Hades taken by Pluto down to his underworld. She might only return to Earth if she had not eaten any of the forbidden fruit in Hades. Unfortunately she had eaten one grain of a pomegranate and therefore was only allowed to return to earth for half a year each spring. Jane Morris was the model for Proserpine at a time when she appeared to be dividing her own life between Morris and Rossetti.*

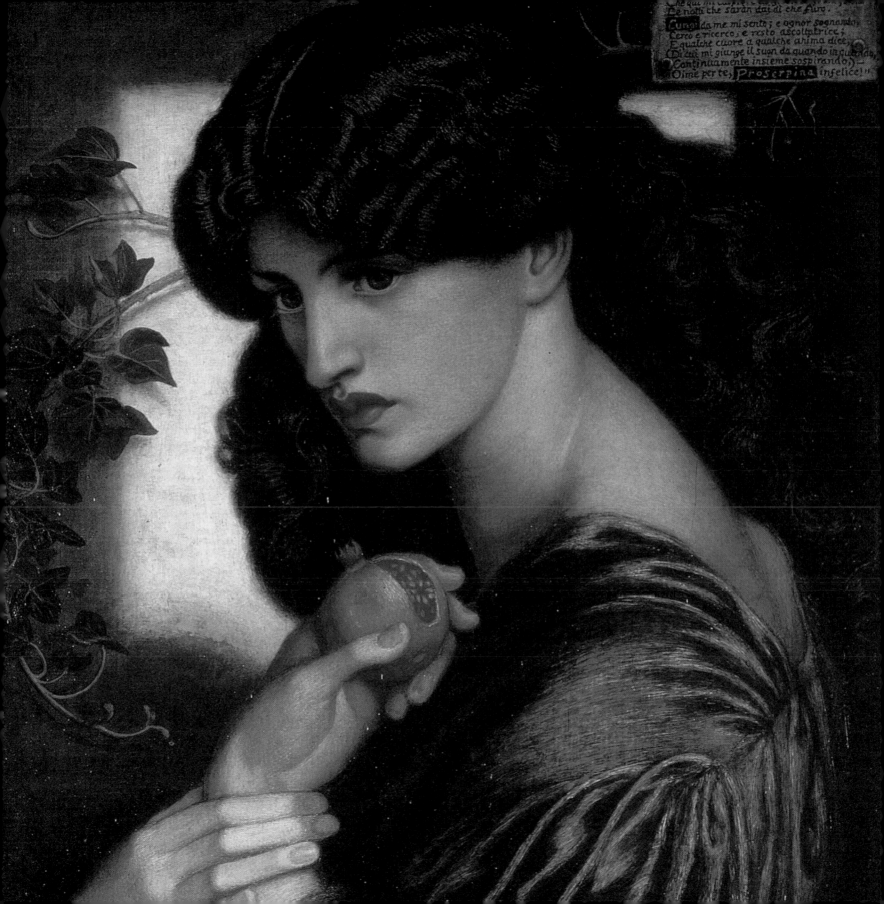

Che qui... ...e futuro.
Le notti che saran dai dì che furo.

Lungi da me mi sento; e ognor sognando,
Cerco e ricerco, e resto ascoltatrice;
E qualche cuore a qualche anima dice,
(Di cui mi giunge il suon da quando in quando,
Continuamente insieme sospirando,) –
Oimè per te, Proserpina infelice!"

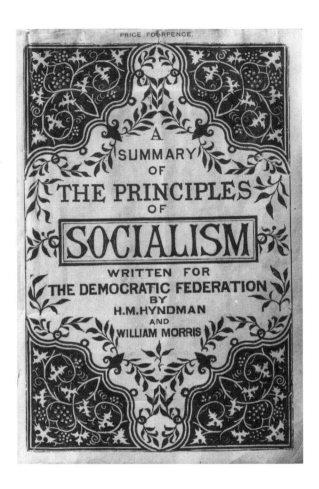

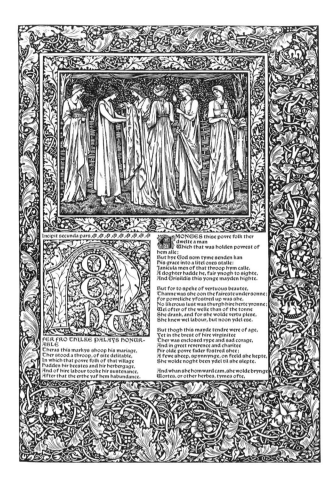

responsible for the interior decoration of St James's Palace in 1881-82. Today Morris designs have universal appeal and are found covering diaries, notebooks, calendars and even mugs, aprons, tea towels and so on.

 Like many of his friends, and other Victorians, Morris harkened back to medieval times, which were seen as a time of style, real craftsmanship and proper social behaviour. He wrote copiously about this period and his many stories and poems are fascinating for those who are enthusiastic to read and enjoy his works. His most enduring and enjoyable novel is probably *News from Nowhere*.

 His writings, particularly his massive poem *The Earthly Paradise* (which is 40,000 lines long), even encouraged some to think of him as a possible successor to Tennyson as Poet Laureate, but Morris's politics were, by this time, not appropriate for that post nor would Queen Victoria have approved of a man who privately referred to her as the 'Empress Brown'.

5. Above left *Front cover of* A Summary of the Principles of Socialism *, 1884*

6. Above right *A page from 'The Kelmscott Chaucer', 1896. The type and borders are by Morris and the illustration by Burne-Jones.*

Morris became active in politics fairly late in life. During his last twenty years or so he spoke publicly on hundreds of occasions and was tireless for the causes he fought for, as he was with everything he undertook. Originally a Liberal, Morris actively entered politics in 1876 when he became treasurer of the Eastern Question Association. He became disenchanted with the Liberal party and in 1883 joined a new political body the socialist based Democratic Federation. The Hammersmith branch of the Federation was set up at Kelmscott House in June 1884. However after disagreements within the Federation, he formed the Socialist League in December 1884 and later the Hammersmith Socialist Society in November 1890. Morris encouraged revolutionary socialism because he believed that real social change would not be achieved by parliamentary means. However he was never an anarchist. He was, as many are, someone who felt that life could, and should, be better than it is and was frustrated as to how best to bring about decent change.

Morris's apparent extremism in politics was, it seems, another example of his style throughout his life. Whether it was writing 40,000 lines of poetry, dyeing fabrics with his arms blue with indigo, weaving tapestry until the early hours, or making twenty speeches a week, he did everything to the limit of his energy and ability.

As his doctor said, he died of doing the work of ten men.

7. Below right *Cartoon drawing of Morris wood cutting. Edward Burne-Jones drew many affectionate caricatures of Morris. This one shows him hard at work carving a wood block for* The Earthly Paradise.

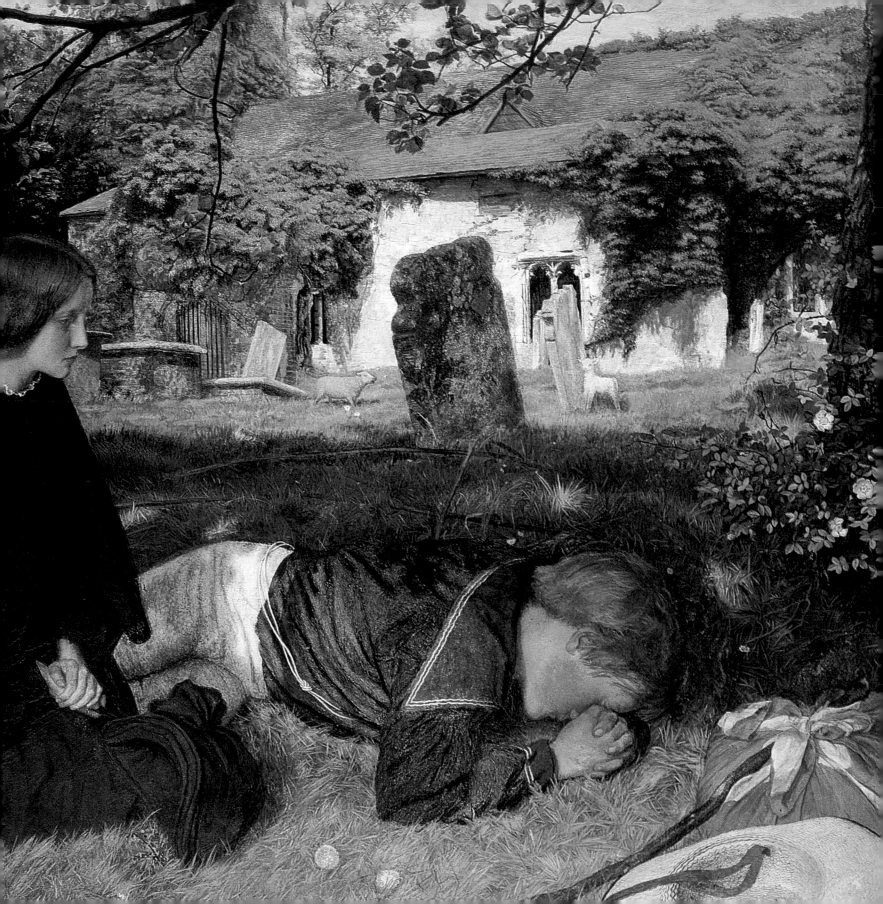

2. CHILDHOOD GARDENS AND EPPING FOREST

Of Morris's early years from 1834 until he went to University in 1853 little of certainty is known. His earliest surviving letter was written to his sister Emma when he was fourteen. It is only from his later writings, reminiscences and letters to friends and daughters that his early days can be pieced together.

Morris was always keen to make clear his 'cockney' origins: 'I was born and bred on the edge of Epping Forest; Walthamstow and Woodford, to wit'. Mackail wrote that Morris 'set his own plain and rather ugly Essex' far above 'the wide arid heaths of Surrey and the close rich Devonshire valleys'. Speaking of the lowlands of Essex Morris said: '... the place being too low and marshy for pleasant dwelling. Past the Docks eastward and landward it is all flat pasture, once marsh, except for a few gardens, and there are very few permanent dwellings there: scarcely anything but a few sheds and cots for the men who come to look after the great herds of cattle pasturing there'. This passage always brings to mind another: 'Ours was the marsh country, down by the river within twenty miles of the sea – and that flat wilderness – intersected with dykes – with scattered cattle feeding on it, was the marshes; and that low leaden line beyond was the river'. This was Pip's description of his first home on the Kent marshes in Charles Dickens's *Great Expectations*, just across the river from where Morris was about twenty years earlier.

Sadly nothing remains of Morris's birthplace, Elm House (sometimes referred to as The Elms) which was in Clay Street, Walthamstow. The Morris family moved to this house from their city home in Lombard Street in 1833 just a few months before William was born. Very little is known about the house and garden. It was flanked by two other large properties, Elm Lodge and Clay Hill House, with a mansion, The Priory, just across the road. It was a very pleasantly situated house. In his biography of Morris, Mackail described Elm House as being a plain roomy building built early in the nineteenth century. The house backed south on to a large lawn surrounded by shrubberies and kitchen gardens, with a great mulberry tree leaning along the grass. The house was demolished, just after Mackail had described it, in 1898. An 1891 sale map shows the Elm House site as being an irregular plot about 450 feet deep by 250 wide. The house had a small lodge and

8. **Left** *Arthur Hughes,* Home from Sea, *1856-63 (Oxford, Ashmolean Museum). Hughes, a plein-air painter in the pre-Raphaelite style, began this painting in 1856 at All Saints' Church, Chingford in Essex. The derelict overgrown church (now restored) is shown amongst wild roses, a yew tree and wild flowers. Hughes once said 'painting wild roses has been a kind of match against time with me'. In 1857 Hughes was one of the original Oxford Union mural painters with Rossetti, Morris and others. He worked for Morris and Company in the 1860s on stained-glass designs.*

was approached by a circular drive which continued through the trees into the rear garden. At the south end of the site were kitchen and, probably, herb gardens. Today there is a small plaque on the fire station wall opposite the site of the house.

The Morris family moved to Woodford Hall from Elm House in 1840 when Morris was six years old. They were to live there for eight years until the death of William Morris senior. The Hall stood in a fifty acre park to the west of the main road, with a further 100 acres to the east and opposite, running down about a mile, to the river Roding. The river Lea was three miles to the west. Both rivers in Morris's time were navigable tributaries of the Thames.

As the crow flies Woodford Hall was about six miles from the Thames and Mackail reminds us: 'From the Hall the course of the Thames might be traced winding through the marshes, with white and ruddy brown sails moving among the cornfields and pastures'.

Woodford Hall was a good-sized Georgian house with two wings. At the southern end of the main building there were steps leading down to the garden from a conservatory. An 1870 map shows a conservatory extending across the full depth of the house and about twenty feet deep, but this this may have been added after the Morrises had left. There were double steps at the front entrance, described as being Palladian style, and at the rear, facing the forest, was a small terrace with single steps. The house was some 250 feet from the main London to Epping road and no road (now Chelmsford Road) is shown north of the house on an 1867 map. The 1870 map also shows two gates into the churchyard and Mackail says the Hall 'had a private doorway into the churchyard'.

Morris spoke affectionately of his childhood at Woodford Hall and told how he and his brothers and sisters had their own gardens and said how he loved the beautiful hepatica when he was a little boy. 'To this day when I smell a may tree I think of going to bed [there] by daylight'. The strong smell of balm always brought to mind his early days in the kitchen garden and the blue plums that grew on the wall beyond the sweet-herb patch.

When we lived at Woodford [Morris wrote to his daughter half a century later], *there were stocks there on a bit of wayside green in the middle of the village: beside them stood the cage, a small shanty some twelve feet square, and it was built of brown brick with blue slate, I suppose it had been quite recently in use, since its style was not earlier than the days of fat George. I remember I used to look at these two threats of law and order with considerable terror, and decidely preferred to walk on the other side of the road.*

9. Above *Elm House, Clay Street, Walthamstow, drawn by E. H. New for Mackail's biography of Morris shortly before the house was demolished. Morris was born here on 24 March 1834 and lived here until 1840.*

11. Below *Ordnance Survey map of 1873 showing the gardens and grounds of Woodford Hall, the Morris family home from 1840-48. The extensive walled kitchen gardens to the north of the house, the proximity of the church, a piece of the avenue left by Repton and the Wilderness and ice house to the south can be clearly seen. In later life Morris used strong words against designed landscapes of this kind.*

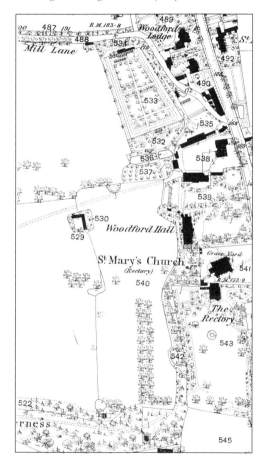

10. Left *Map of Elm House and its gardens from a survey made for a sale in 1891. The layout is very similar to that shown in the first edition of the Ordnance Survey of about 1863, some twenty years after the Morris family had left.*

For a description of the Hall and its gardens it is interesting to read the correspondence between the famous landscape gardener, Humphry Repton (1752-1818), and John Maitland in 1801. It was from the Maitland family that William Morris senior leased Woodford Hall.

The following notes are Repton's suggestions for improvements to the walks and flower garden at Woodford Hall:

It is impossible to find a better situation than that proposed for the Conservatory, attached to the house, with a proper Aspect, and connected with the principal rooms.

The ground before this South front is at present an unsightly corner, with the Church Yard partially concealed; this I propose converting into a Flower Garden and to remove the present unmeaning walk, that runs close under the Churchyard wall: this pleasure ground may be extended through the whole of the narrow piece of ground between the Parsonage Garden and the Avenue, and will form the natural connection between the house and the Walks in the wood[s?]; perhaps this flower garden may be varied by an irregular pool of Water, if the supply and colour should make it desirable, the banks of which may be covered with water lilies, and the various kinds of aquatic plants, whilst the ground is broken by groups of flowers and flowering shrubs forming irregular glades of grass: or the whole of this place might be allotted to American trees and shrubs, and converted into a Garden for hardy exotic plants – The Kitchen Garden will be sufficiently removed out of sight by being placed as described on the Map....

The principle Walk in the Wood, is at present formal, with a straight hedge and plantation of Firs.... and many of the Firs may be taken away, where they oppress better trees, and present a spiral outline, or fill up recesses, that would be more interesting when cleared.

This management will be most essential in the West corner near the Forest, for I consider the Forest as the principal beauty of the Situation, and of which every advantage should be taken. After passing this Corner the walk will naturally divide into two branches, one leading to the proposed building in the Forest, which will be a feature to the whole country, and command beautiful and entirely new Scenery; and the other to the Poultry Yard, which may be an interesting Appendage to the place; from hence a walk may return to the House by the Avenue, which will properly be preserved: but the other when broken by taking away the Trees which I mark on the Spot, will lose the appearance of an Avenue, except when viewed from either end.

It will sometimes be objected that I have not sufficiently reprobated or corrected the many strait lines, with which these grounds abound, because we are told by the Serpentine Improvers of modern Gardening that 'Nature abhors a strait line'....

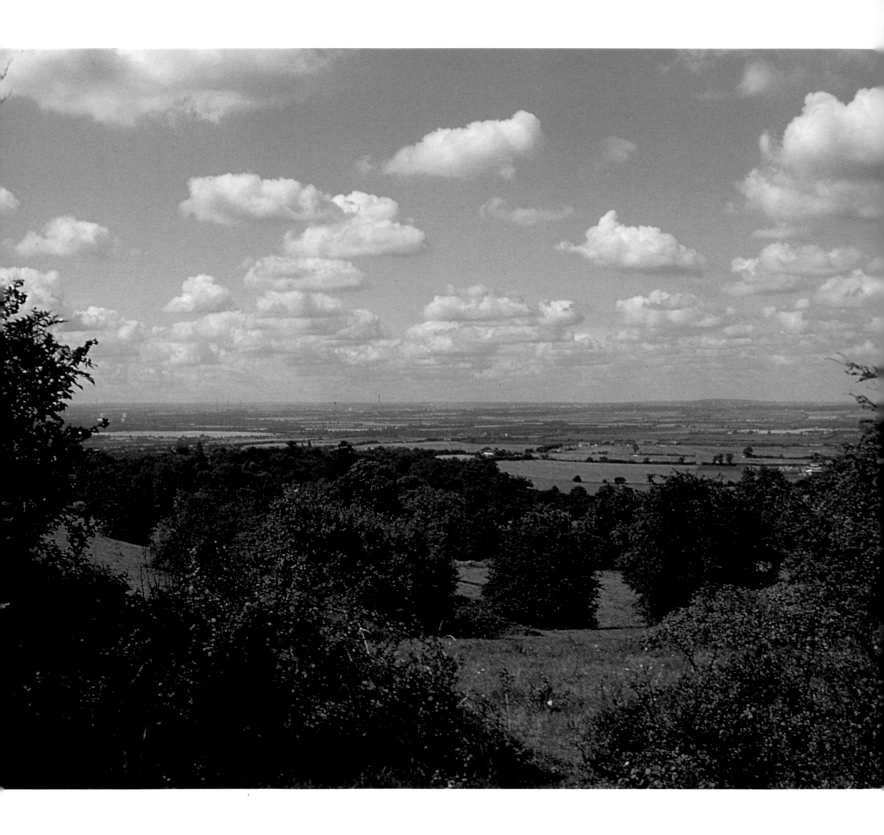

12. Left *Photograph of the view over the Essex marshes taken by the author. The view from Langdon Hills today is very much as it was over 100 years ago. In* News from Nowhere *Morris wrote, 'It does not make a bad holiday to get a quiet pony and ride about there on a sunny afternoon of autumn and look over the river and the craft passing up and down, and on to Shooter's Hill and the Kentish uplands, and to turn round to the wide green sea of the Essex marshland, with the great domed line of the sky'.*

It appears Humphry Repton (1752-1818) was commissioned by John Maitland in 1801 to consider and lay out the grounds of Woodford Hall. Repton sometimes worked in association with John Nash and at about this time the Prince Regent had invited him to prepare a scheme for the grounds of the Brighton Pavilion. He lived much of his life in Romford, Essex, only eight miles from Woodford Hall and was a highly successful landscape gardener.

Today Humphry Repton is remembered for his famous Red Books. These were filled with watercolour illustrations of garden designs demonstrating to the client 'before' and 'after' impressions of the garden by means of overlying flaps to show the suggested effects. It is believed there still exists a Red Book for Woodford Hall but its whereabouts are not known. It is likely that Repton's descriptions of the proposed gardens would correspond closely with the gardens as they were when the Morris family leased the house in 1840.

After the death of his father, in the autumn of 1848, Morris's mother, Emma, moved to the Water House, Clay Street (later renamed Forest Road), Walthamstow. The Water House was built around 1750 and is now the William Morris Gallery in Lloyd Park and part of the London Borough of Waltham Forest. The house has had many names. On the 1863 map it was called 'The Winns' and its history goes back to ancient times, with a house on the moated site.

In his letter, 1 November 1848, from Marlborough to his sister Emma Morris says he is looking forward to coming home to the new house. It is clear he had not yet seen the house and was uncertain as to which house it was. To Emma's description of the house he replies, 'I can't understand which one you mean'. He says he knows it is not 'our old house' meaning Elm House which was about 800 yards west up Clay Hill.

Morris seldom used the Water House as a home, having gone to Marlborough College about eight months before the family moved. On leaving school in December 1851 he returned to the Water House to study privately for his University entrance examination with the Revd Guy in Hoe Street, Walthamstow. In January 1853, Morris went to Exeter College, Oxford.

Mackail tells us the Water House garden had a broad lawn leading down to a moat some forty feet wide and an island planted with a grove of aspens and thickly wooded with hollies, hawthorn and chestnuts. In this moat the boys fished and bathed, played at being Indians, went boating in summer and skating in winter. The island was reached by three foot bridges and there was a boathouse.

In an 1854 sale notice the house is described as having a walled kitchen garden with a tool house, larder and potato house and a melon ground. The 'pleasure grounds' had broad gravelled walks, shrubberies, a large sheet of water with island, plantation and rustic bridge. There was a greenhouse, an 'American' shrubbery, a small paddock and pasture field. The outbuildings included a stable and harness room with a loft over the coach house.

13. *Left Photograph of the Water House taken in the 1860s by the Stereoscopic Company. Mrs Morris lived here from 1848-56.*

14. **Below** *Plan drawn in a title deed of 1847 of The Winns (later the Water House) and its grounds (London Borough of Waltham Forest archives, deed BRA333.78.) The moat where Morris fished and swam has always been a very striking feature of the site. It is now known as Lloyd Park and is cared for by the local authority. During the 1996 William Morris centenary year new trees will be planted in the park to celebrate his life. The trees will be species named in Morris's poem 'Tapestry Trees' given opposite.*

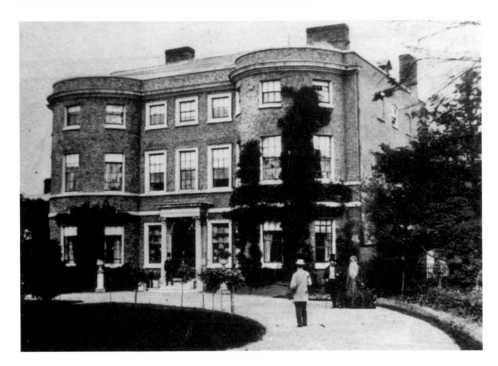

Edward Burne-Jones visited the house in the summer of 1853 and in 1855 Morris spent his Easter and summer holidays there, and it was here in the autumn of 1855 that he began to be concerned with thoughts of his future. On 11 November Morris wrote to his mother from Oxford, telling her he planned to become an architect instead of taking Holy Orders. Morris graduated from Oxford later that year and began living away from the family home in lodgings both in London and Oxford. The Morris family left the house in 1856 and Mrs Morris went to Leyton House. May Morris later recalled visits to her grandmother there.

Two forests featured in Morris's early life. When he was at school at Marlborough, between February 1848 and December 1851, he used to take long walks in Savernake Forest. But the first, and last, forest in his life was Epping Forest in Essex and it was there that Morris's lifelong interest in and love of nature

TAPESTRY TREES

Oak I am the Roof-tree and the keel;
I bridge the seas for woe and weal.

Fir High o'er the lordly oak I stand,
And drive him on from land to land.

Ash I heft my brother's iron blade;
I shaft the spear, and build the wain.

Yew Dark down the windy dale I grow
The father of the fateful bow.

Poplar The war-shaft and the milking bowl
I make, and keep the hay-wain whole.

Olive The king I bless; the lamps I trim;
In my warm wave do fishes swim.

Apple I bowed my head to Adam's will;
The cups of toiling men I fill.

Vine I draw the blood from out the earth;
I store the sun for winter mirth.

Orange Amidst the greenness of my night,
My odorous lamps hang round and bright.

Fig I who am little among trees
In honey-making mate the bees.

Mulberry Love's lack hath dyed my berries red:
For love's attire my leaves are shed.

Pear High o'er the mead flower's hidden feet
I bear aloft my burden sweet.

Bay Look on my leafy boughs, the Crown
Of living song and dead renown.

*From Morris's book of collected poems,
Poems by the Way printed in 1891.*

had its origins. Years later he wrote with pride and nostalgia, 'when I was a boy and young man I knew it yard by yard'.

As a young boy Morris spent much time in and around west and south-east Essex on his pony – in Epping Forest and the villages of Essex and Hertfordshire. He did brass rubbings in St Michael's Church in Aveley and in St Mary's, Stifford. He was a good rider and it is most probable he travelled, like Cobbett, on horseback covering some ten miles a day. Philip Webb in later years recalled how he and Morris went riding on Mrs Morris's carriage horses to the Roman camp at Amesbury Banks and to Theydon Bois and then to Chingford. If and where he stayed overnight on these trips is not known, but travelling from Woodford down to Stifford and Aveley and back would have been a long tiring thirty mile ride.

As a child historical Epping Forest was Morris's playground literally just through the garden gate of his parents' home at Woodford Hall. It is not difficult to see how the young Morris was intrigued by it. He says he knew every yard of the forest from the Theydons to Wanstead and from Hale End to Fairlop Oak, an area of about thirty to forty square miles.

According to Mackail, Morris never ceased to love Epping Forest: 'the dense hornbeam thickets, which even in bright weather have something of solemnity and mystery in their deep shade'. One of his most revealing descriptions is when he speaks of its hornbeam trees. He says, in a letter to the *Daily Chronicle* in May 1895, 'Nothing could be more interesting and romantic than the effect of the long poles of the hornbeams rising from the trunks and seen against the mass of the wood behind. It has a peculiar charm of its own not to be found in any other forest'. Compare this letter to the passage in *News from Nowhere* when William Guest (that is to say Morris himself) is talking to Dick and Robert the weaver,

When I was a boy, and for a long time after, except for a piece about Queen Elizabeth's lodge, and for the part about High Beech, the Forest was almost made up of pollard hornbeams mixed with holly thickets. But when the Corporation of London took it over about twenty-five years ago, the topping and lopping, which was a part of the old commoners rights, came to an end, and the trees were let to grow.

Again from *News*:

Dear neighbour, since you knew the forest some time ago, could you tell me what truth there is in the rumour that in the nineteenth century the trees were all pollards? That was catching me on my archaeological natural-history side, and I fell into the trap without any thought.

Pollarding was discontinued in Epping at Great Monkwood around 1840 and because of this the forest is almost more impressive today, despite Morris's later fears of its destruction, as the unpollarded hornbeams 150 years on now rise to heights of 80 feet or more. Today most of the hornbeams are in the northern part of the forest near Great Monkwood.

To Morris pollarding was not just an interesting annual arboricultural event, it was a feature of the forest which reflected the life and times of the people who had lived in and around the forest since ancient times. Pollarding is an ancient system of forest management whereby the grazing of animals in forest or wood pastures can be combined with the production of wood. The trees are lopped at a height of about six to nine feet above where cattle might graze and are cropped every seven to fifteen years. An alternative to pollarding is coppicing, where the trees are felled at ground level.

In the sixteenth century pollarding was regulated by the manorial court but it was accepted that cottagers, inhabitants and others were entitled to remove pollarded wood from the forest for firewood, usually known as common or custom wood. To prevent exploitation and commercialisation of the practice the court ruled that the locals should not use mechanical means to transport the wood. All had to be carried manually to the homes of the inhabitants of the forest. In addition only one man per household was allowed to lop and transport the wood. The earliest recorded date of pollarding in Epping Forest is 1365, but it is believed the practice may have its origins in Saxon times. Fencemaking was also an activity and Morris refers to the 'rolling fence maker' in a letter to the *Daily Chronicle*. The main forest industry was charcoal burning.

Today the 6,000 acre forest is the remaining remnant of the 60,000 acre royal forest of Essex – the favourite hunting ground of English sovereigns for more than 600 years. After falling into decay it was saved from illegal closure in the mid nineteenth century by the timely intervention of the Corporation of London. A major common rights action by the City of London Corporation was a court ruling preventing the forest from being subject to the Enclosures Acts. Under the Epping Forest Act of 1878 the forest was vested in the Corporation as Conservators, on their undertaking to keep it unenclosed and free from all buildings. Contrary to popular belief it was not given to the public by Queen Victoria as it was never hers to give. It belonged to the lords of its nineteen manors who were bought out by hard cash.

15. Right *Hornbeams in Epping Forest in a photograph by the author. These trees have not been pollarded for about 150 years and now reach heights of 80 feet and more. Pollarding of trees was a method of forest management which ensured an indefinite supply of wood while protecting the trees from grazing animals.*

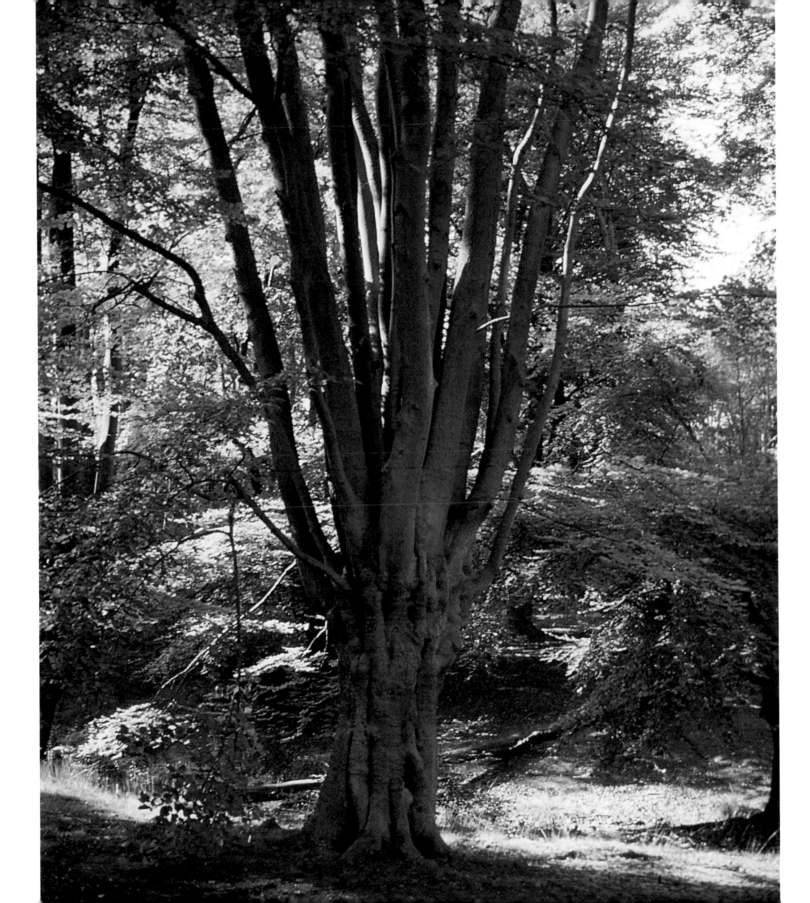

William Morris recalled Queen Elizabeth's Lodge by Chingford Hatch in Epping Forest and described 'a room hung with faded greenery' [tapestry]. Queen Elizabeth's hunting lodge at Chingford was, in fact, built by Henry VIII as a hunting grandstand and the rooms were originally open balconies for viewing the hunt.

Royal use of the forest began in Norman times but after the Commonwealth the forest laws fell into disuse and the royal use of the forest ended. In the eighteenth century Defoe recorded his impressions of the changing nature of the forest, particularly the increase in the number of houses owned by wealthy city folk. Woodford Hall was one such development. It was this demographic trend that gradually transformed the forest's royal connection into one with more links with the City of London. The King's Hunt was replaced by the Lord Mayor's Hunt, for example.

In early 1895 the newspapers reported excessive tree felling in Epping Forest and in response William Morris wrote to the *Daily Chronicle* on 22 April 1895 (published 23 April) as follows:

Sir, I venture to ask you to allow me a few words on the subject of the present treatment of Epping Forest.

I was born and bred in its neighborhood (Walthamstow and Woodford) and when I was a boy and young man knew it yard by yard from Wanstead to the Theydons and from Hale End to Fairlop Oak. In those days it had no worst foes than the gravel stealer and the rolling fence maker, and was always interesting and often very beautiful. From what I can hear it is years since the greater part of it has been destroyed and I fear, Sir, that in spite of your late optimistic note on the subject, what is left of it now runs the danger of further ruin.

The special character of it was derived from the fact that by far the greater part was a wood of hornbeams, a tree not uncommon in Essex and Herts. It was certainly the biggest hornbeam wood in these islands and I suppose in the World. [Note this is partly supported by a statement by the Essex Field Club (1994) who claim it is the largest in western Europe.] *The said hornbeams were all pollards, being shrouded every four or six years, and were interspersed with holly thickets; and the result was a very curious and characteristic wood such as can be seen nowhere else. And I submit that no treatment of it can be tolerable which does not leave this hornbeam wood intact.*

But the hornbeam, though an interesting tree to an artist and reasonable person, is no favourite with the landscape gardener and I very much fear that the intention of the authorities is to clear the forest of its native trees and to plant vile weeds like deodars and

16. Above *A poster urging public protest against enclosing parts of Epping Forest.*

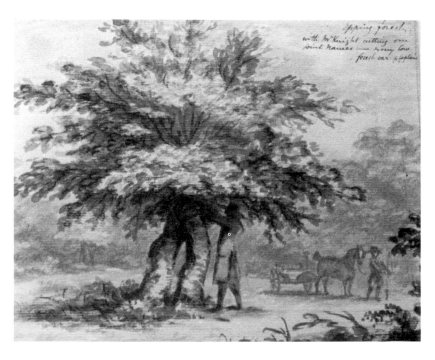

17. Right *A watercolour sketch by Humphry Repton inscribed by him, 'Epping Forest, with Mr Knight cutting our joint names – very low – forest car & Captain'. Repton spent much of his life in south-west Essex, which may have been why he was an obvious choice for the improvements to Woodford Hall.*

outlandish conifers instead. We are told that a committee of 'experts' has been formed to sit in judgment on Epping Forest: but, Sir, I decline to be gagged by the word 'expert', and I call on the public generally to take the same position.

An 'expert' may be a very dangerous person, because he is likely to narrow his views to the particular business (usually a commercial one) which he represents. In this case, for instance, we do not want to be under the thumb, of either a wood bailiff, whose business is to grow timber for the market, or of a botanist whose business is to collect specimens for a botanical garden; or of a landscape gardener whose business is to vulgarise a garden or landscape to the utmost extent that his patron's purse will allow of. What we want is reasonable men of real artistic taste to take into consideration what the essential needs of the case are, and to advise accordingly.

Now it seems to me that the authorities who have Epping Forest in hand may have two intentions to it. First they may intend to landscape garden it, or turn it into golf grounds (and I fear that even the latter nuisance may be in their minds) or second, they may really think it is necessary (as you suggest) to thin the hornbeams, so as to give them a better chance of growing. The first alternative we Londoners should protest against to the utmost. For if it be carried out then Epping Forest is turned into a mere piece of vulgarity, is destroyed in fact.

As to the second, to put our minds at rest, we ought to be assured that the cleared spaces would be planted again, and that almost wholly with hornbeam. And, further the

greatest possible care should be taken that not a single tree should be felled, unless it were necessary for the growth of its fellows. Because, mind you, with comparatively small trees, the really beautiful effect of them can only be got by their standing as close together as the exigencies of growth will allow. We want a thicket not a park, for Epping Forest.

In short, a great and practically irreparable mistake will be made, if under the shelter of the opinion of experts, from mere callousness and thoughtlessness, we let the matter slip out of our hands of the thoughtful part of the public: the essential character of one of the greatest ornaments of London will disappear, and no one will have even a sample left to show what the great north-eastern forest was like.

I am, Sir, yours obediently,

William Morris. Kelmscott House. 22nd April 1895

After sending this letter to the *Daily Chronicle* Morris reflected on the matter and felt he should not rely on newspaper reports. He decided to check the state of the forest for himself. So, on 7 May 1895 Morris, with his friends Philip Webb, Emery Walker, Fred Ellis, his publisher, and Sydney Cockerell, his secretary and later his executor, set off to inspect the forest. Cockerell later wrote:

My diary records that it was a warm and cloudless day and that the young green of the beeches, mingled with the darker tone of the hornbeams, was very beautiful: – we walked from Loughton via Monkwood, Theydon Bois; High Beech, and Bury Wood, to Chingford, and laughed and talked and enjoyed every moment.

This six mile walk was probably the most enjoyable and energetic day Morris experienced before his death seventeen months later. According to Mackail, Morris was relieved to find that the reports of damage to the trees were exaggerated and he felt he must, following his earlier protest letter, submit his own report on the state of the forest to the *Daily Chronicle*. This report was printed in the paper on 9 May 1895:

Sir, Yesterday I carried out my intention of visiting Epping Forest... I can verify closely your representative's account of the doings on Clay Road, which is an ugly scar originally made by the lord of the manor when he contemplated handing over to the builder a part of what he thought was his property. The fellings here seemed to me all pure damage to the forest and in fact were quite unaccountable to me, and surely would be so to any unprejudiced person. I cannot see what could be pleaded for them either on the side of utility or taste.

About Monk Wood there had been much, and I should say excessive, felling of trees apparently quite sound. This is a very beautiful spot, and I was informed that the trees

18. Right *Detail from J. W. Inchbold's* A Study in March *(sometimes called* In Early Spring*), first exhibited in 1855 (Oxford, Ashmolean Museum). Described by John Ruskin as 'exceedingly beautiful', the delightfully painted woodland flowers in the foreground show the pre-Raphaelite preoccupation with detail.*

there had not been polled for a period long before the acquisition of the forest for the public: and nothing could be more interesting and romantic than the effect of the long poles of the hornbeams rising from the trunks and seen against the wood behind.

This wood should be guarded most jealousy as a treasure of beauty so near 'the Wen'. In the Theydon Woods, which are mainly of beech, a great deal of felling has gone on, to my mind quite unnecessary and therefore harmful. On the road between the wake Arms and the King's Oak hotel there has been again much felling, obviously destructive.

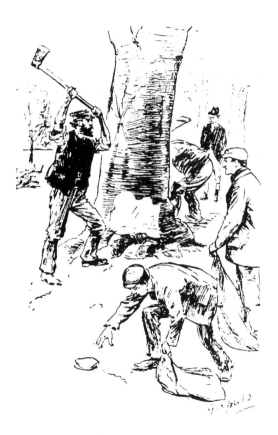

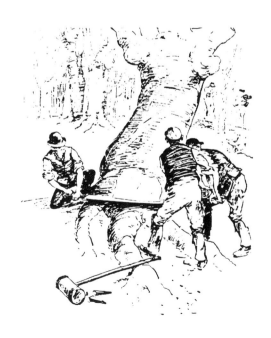

19 and 20. Left and below *These sketches appeared in the* Daily Graphic, *14 April 1894, and drew attention to excessive tree felling in Epping Forest.*

In Bury Wood (by Sewardstone Green) we saw the trunks of a great number of oak trees (not pollards) all of them sound: and a great number were yet standing in the wood marked for felling, which however, we heard had been saved by a majority of the committee of experts. I can only say that it would have been a very great misfortune if they had been lost: in almost every case where the stumps of the felled trees showed there seemed to have been no reason for their destruction. The wood on the other side of the road to Bury Wood, called on the map Woodman's Glade, has not suffered from felling, and stands as an object lesson to show how unnecessary such felling is. It is one of the thickest parts of the forest, and looks in

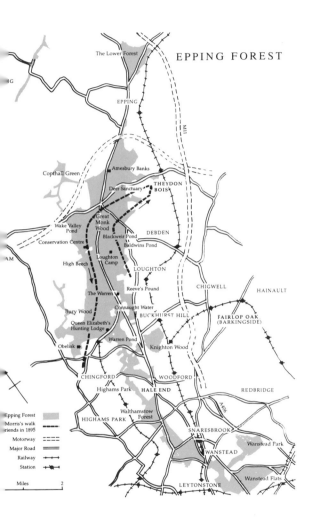

EPPING FOREST

21. **Above** *Sketch map showing the route of the walk Morris took through Epping Forest with his friends in 1895 only seventeen months before his death. In the nineteenth century Epping Forest covered about 6,000 acres and Morris claimed he knew every yard of thirty to forty square miles of it.*

all respects like such woods were forty years ago, the growth of the heads of the hornbeams being but slow; but there is no difficulty in getting through it in all directions, and it has a peculiar charm of its own not to be found in any other forest; in short, it is thoroughly **characteristic**. I should mention that the whole of these woods are composed of pollard hornbeams and 'spear' -i.e. unpolled - oaks.

I am compelled to say, from what I saw in a long day's inspection, that, though no doubt acting with the best intentions, the management of the forest is going on the wrong tack; it is making war on the natural aspect of the forest, which the Act of Parliament that conferred it on the nation expressly stipulated was to be retained. The tendency of all these fellings is on the one hand to turn a London forest into a park, which would be more or less like other parks, and on the other hand to grow sizeable trees as if for the timber market. I must beg to be allowed a short quotation here from an excellent little guidebook to the forest by Mr Edward North Buxton, Verderer of the Forest. (Stanford 1885). he says p38:-

'In the drier parts of the forest, beeches to a great extent take the place of oaks, these 'spear' trees will make fine timber for future generations, provided they receive timely attention by being **relieved of the competing growth of the unpicturesque hornbeam pollards**. Throughout the wood, between Chingford and High Beach, **this has been recently done**, to the great advantage of the finer trees'

The italics are mine, and I ask, Sir, if we want any further evidence than this of one of the Verderers as to the tendency of the fellings.

Mr Buxton declares in so many words that he wants to change the special character of the forest; to take away this strange unexampled, and most romantic wood, and leave us nothing but a commonplace instead. I entirely deny his right to do so in the teeth of the Act of Parliament. I assert, as I did in my former letter, that the hornbeams are the most important trees in the forest, since they give it its special character.

At the same time, I would not encourage the hornbeams at the expense of the beeches, any more than I would the beeches at the expense of the hornbeam; I would leave them all to nature, which is not so niggard after all, even in Epping Forest gravel, as, e.g., one can see in places where forest fires have denuded spaces, and where in a short time birches spring up self sown.

The Committee of the Common Council has now had Epping Forest in hand for seventeen years, and has, I am told, in that time felled 100,000 trees. I think the public may now fairly ask for a rest on behalf of the woods.

William Morris. Kelmscott House.

8th May 1895

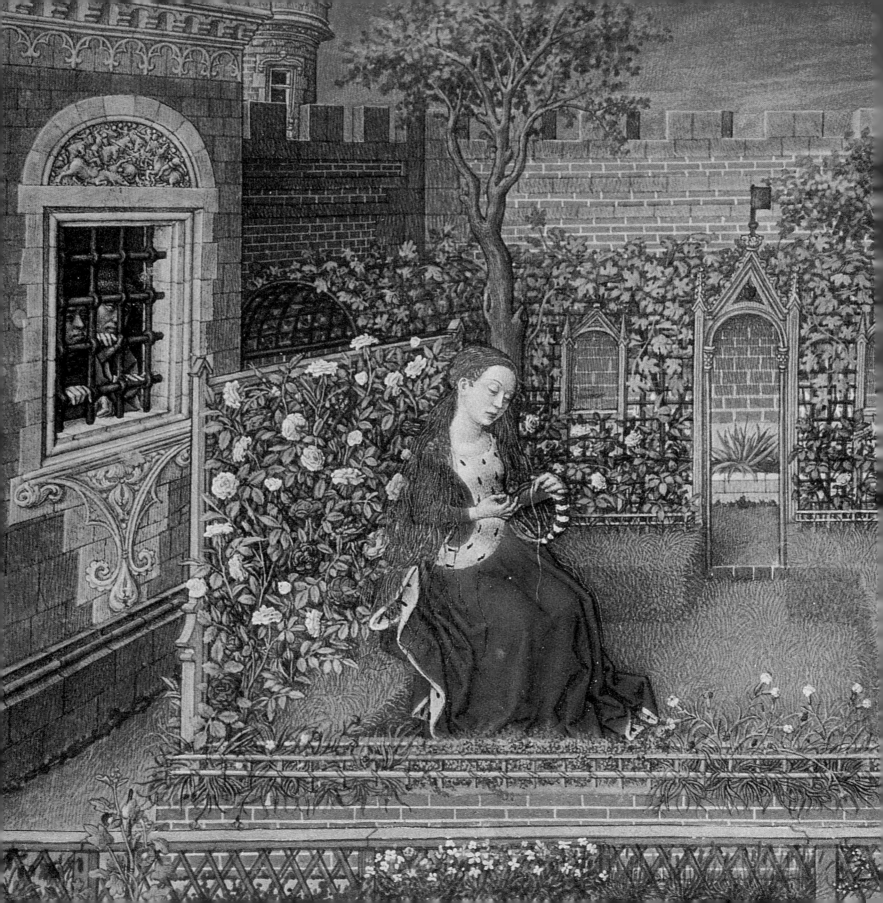

3. OXFORD, RUSKIN AND THE PRE-RAPHAELITES

While at college in Oxford between 1853 and 1855 William Morris and Edward Burne-Jones had many opportunities to study and be impressed by plants and flowers. This was a time when botanical subjects were popular and becoming important topics in product design and architecture.

Morris studied in the Bodleian Library, which overlooked the small but beautiful Fellow's garden of his own college and other old college gardens, some going back to medieval times, and he no doubt knew the Ashmolean Museum, with its collection of Dutch flower paintings and its connection with the Elizabethan plant hunters, the Tradescants. Although there is no evidence of Morris visiting the Oxford Botanic Gardens it is most unlikely he did not do so, taking away information about plant hunters, the flower painters and the new plants then being imported. It is also said Burne-Jones and Morris 'went on angry walks together in the afternoons', and Burne-Jones 'spent whole days in Bagley Wood making minute and elaborate studies of flowers and foliage'.

'The Story of the Unknown Church' appeared in the first *Oxford and Cambridge Magazine* on 1 January 1856. It was the first of Morris's stories to be published, albeit Morris was the editor and funded the publishing costs. The story, said to be one of Morris's best early prose romances, is the recall of a dead stonemason who had worked on the west front of a cathedral (possibly Amiens or Chartres) in the thirteenth century. The story begins as the mason remembers the town and its environs where the church was being built. His sister Margaret is, strangely, also a stonemason and carves the flowers. Her lover, Amyot, has been away fighting in the holy wars:

The Abbey where we built the Church was not girt by stone walls, but by a circle of poplar trees, and when ever a wind passed over them, were it ever so little a breath, it set them all a-ripple; and when the wind was high, they bowed and swayed very low, and the wind, as it lifted the leaves, and showed their silvery white sides, or as again in the lulls of it, it let them drop, kept on changing the trees from green to white, and white to green; moreover, through the boughs and trunks of the poplars, we caught glimpses of the great golden corn sea, waving, waving, waving for leagues and leagues; and among the corn grew burning

22. Left *A nineteenth-century copy of a page from a fifteenth-century manuscript illustrating one of Boccaccio's stories. The enclosed garden with its trellis and fine lady making garlands is typical of the kind of medieval image that appealed to the romantic in Morris and his friends at Oxford.*

scarlet poppies, and blue corn-flowers; and the corn-flowers were so blue, that they gleamed, and seemed to burn with a steady light, as they grew beside the poppies among the gold of the wheat.... on the north side of the Church, and joined to it by a cloister of round arches, and in the midst of the cloister was a lawn, and in the midst of that lawn, a fountain of marble, carved round about with flowers and strange beasts; at the edge of the lawn, near the round arches, were a great many sun-flowers that were all in blossom on that autumn day; and up many of the pillars of the cloister crept passion-flowers and roses. Then, farther from the Church, and past the cloister and its buildings, were many detached buildings, and a great garden round them, all within the circle of the poplar trees; in the garden were trellises covered over with roses, and convolvulus, and the great-leaved fiery nasturtium; and specially all along by the poplar trees there were trellises, but on these grew nothing but deep crimson roses; the hollyhocks too were all out in blossom at that time, great spires of pink, and orange, and red, and white, with their soft, downy leaves. I said that nothing grew on the trellises by the poplars but crimson roses, but I was not quite right, for in many places the wild flowers had crept into the garden from without, lush green briony, with green-white blossoms, that grows so fast, one could almost think that we see it grow, and deadly nightshade, La bella donna, O! so beautiful; red berry, and purple, yellow-spiked flower, and deadly, cruel-looking, dark green leaf, all growing together in the glorious days of early autumn.

The mason's last carving on the church is of Abraham and as he works he dreams of a land where there was 'a great sea of corn-poppies, only paths of white lilies wound all among them, with here and there a great golden sunflower'. In his dreams he meets Amyot, his friend and sister's lover, who has now been injured in the wars and sees, 'growing in a cranny of the worn stones, a great bunch of golden and blood-red wallflowers, and I watched the wallflowers and banner for long'. When he awakes Amyot has arrived home but is dying. After Amyot's death Margaret also dies. The mason carves a tomb for the two lovers and, grieving, becomes a monk within the church, continuing to carve until his own death carving 'the last lily of the tomb'.

William Morris and Edward Burne-Jones first became seriously acquainted with Ruskin's writings while they were at Oxford. Morris had already read the first two volumes of Ruskin's *Modern Painters* in 1853 just before he went to Oxford, but it was during his first year there that he read the famous chapter 'On the Nature of Gothic' from the *Stones of Venice* and *The Seven Lamps of Architecture*. In the following year both young men learned more about their 'hero and

23. Below *John Ruskin by Hubert von Herkomer, 1879 (London, National Portrait Gallery). Throughout his life Morris was influenced by John Ruskin. Of Ruskin's writings the late Sir Kenneth Clark said, 'Ruskin's moralistic theories of art are not Ruskin for today: but they may be Ruskin for tomorrow'.*

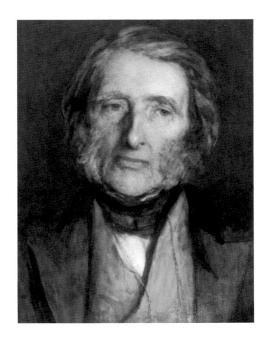

24. Above *A study of ivy drawn by Ruskin at Brantwood in 1879 (The Ruskin Galleries, Bembridge School, Isle of Wight). In his autobiography* Praeterita *Ruskin wrote, 'Considering of these matters, one day on the road to Norwood, I noticed a bit of ivy round a thorn stem, which seemed, even to my critical judgment, not ill 'composed'; and proceeded to make a light and shade pencil study of it in my grey paper pocket book, carefully, as if it had been a bit of sculpture, liking it more and more as I drew. When it was done, I saw that I had virtually lost all my time since I was twelve years old, because no one had ever told me to draw what was really there! All my time, I mean, given to drawing as an art; of course I had records of places, but had never seen the beauty of anything, not even of a stone – how much less of a leaf!'*

prophet' when Ruskin's *Edinburgh Lectures* were published. It was from these writings and the subsequent discussions with his friends that Ruskin's lifelong influence developed.

There is little purpose in speculating on the influence of John Ruskin on William Morris. In Morris's own eulogies and appreciations of Ruskin are found the source of many of his own ideas about nature, beauty, socialism and art. Nor is it difficult to see the impact Ruskin had on the young enthusiastic undergraduate.

Over a period of forty years or so, Morris wrote:

I should have to excuse myself to you for saying any more about this, when I remember how a great man now living has spoken of it: I mean my friend Professor John Ruskin: if you read the chapter in the second volume of his 'Stones of Venice' entitled, 'On the Nature of Gothic, and the Office of the Workman therein', you will read at once the truest and the most eloquent words that can possibly be said on the subject....

To my mind – The Nature of Gothic – is one of the most important things written by [Ruskin], and in future days will be considered as one of the very few necessary and inevitable utterances of the century. To some of us when we first read it (in those dawn golden days at Oxford) now many years ago, it seemed to point out a new road on which the world should travel. The lesson which Ruskin teaches us is that art is the expression of man's pleasure in labour; that it is possible for man to rejoice in his work....

Before my days of practical Socialism, [Ruskin] was my master – and, looking backward, I cannot help saying, – how deadly dull the world would have been twenty years ago but for Ruskin....By a marvellous inspiration of genius (I can call it nothing else) he attained at one leap to a true conception of medieval art, which years of minute study had no others.

In his preface to the 1892 Kelmscott Press edition of *The Nature of Gothic* Morris said John Ruskin had given the keenest of pleasure to thousands of readers by his lifelike descriptions of nature and art. Ruskin's feeling for nature and his skill as an artist and 'word painter' is shown in this beautiful passage from his book *Studies of Wayside Flowers - Proserpina*:

*I have in my hand a small red poppy which I gathered on Whit Sunday on the palace of the Caesars. It is an intensely simple, intensely floral, flower. All silk and flame: a scarlet cup, perfect-edged all round, seen among the wild grass far away, like a burning coal fallen from Heaven's altars. You cannot have a more complete, a more stainless, type of flower absolute; inside and outside, **all** flower. No sparing of colour anywhere — no outside*

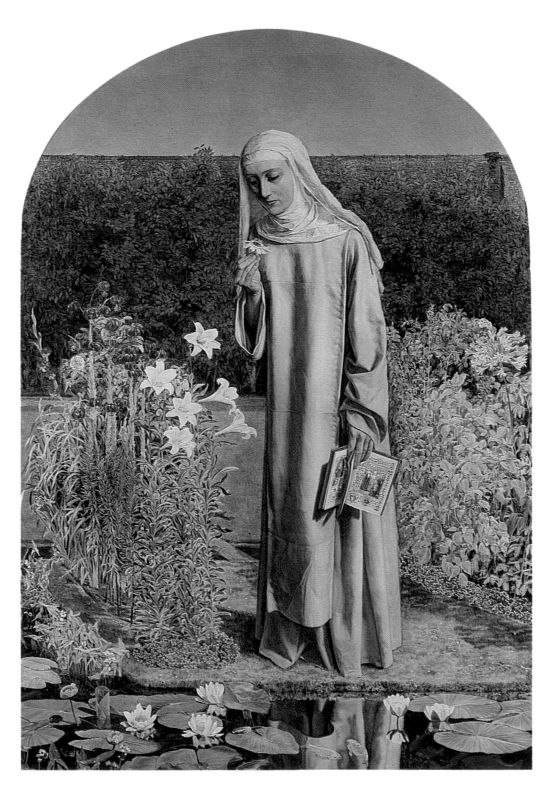

25. **Left** *Charles Allston Collins,*
Convent Thoughts, 1850 *(Oxford, Ash-
molean Museum). Collins was only twenty-
three when he painted this picture. It was later
owned by Ruskin who said he had 'never seen
flowers so thoroughly or well drawn before'.
Among the many flowers is the symbolic
Passion flower* (Passiflora caerulea)*. The
story goes that the early Spanish missionaries
in South America looked for signs of Christ's
Passion in the flower. The waterlily is the*
Alisma plantago, *again much praised by
Ruskin.*

26. **Right** *John Everett Millais,*
Ophelia *(detail), 1852 (London, Tate Gallery).
Millais described himself painting on the banks
of the Hogsmill river: 'I sit tailor fashion under
an umbrella throwing a shadow scarcely larger
than a halfpenny for eleven hours, with a
child's mug within reach to satisfy my thirst
from the running stream beside me... am also in
danger of being blown by the wind into the
water, and becoming intimate with the feelings
of Ophelia when that lady sank to her muddy
death'.*

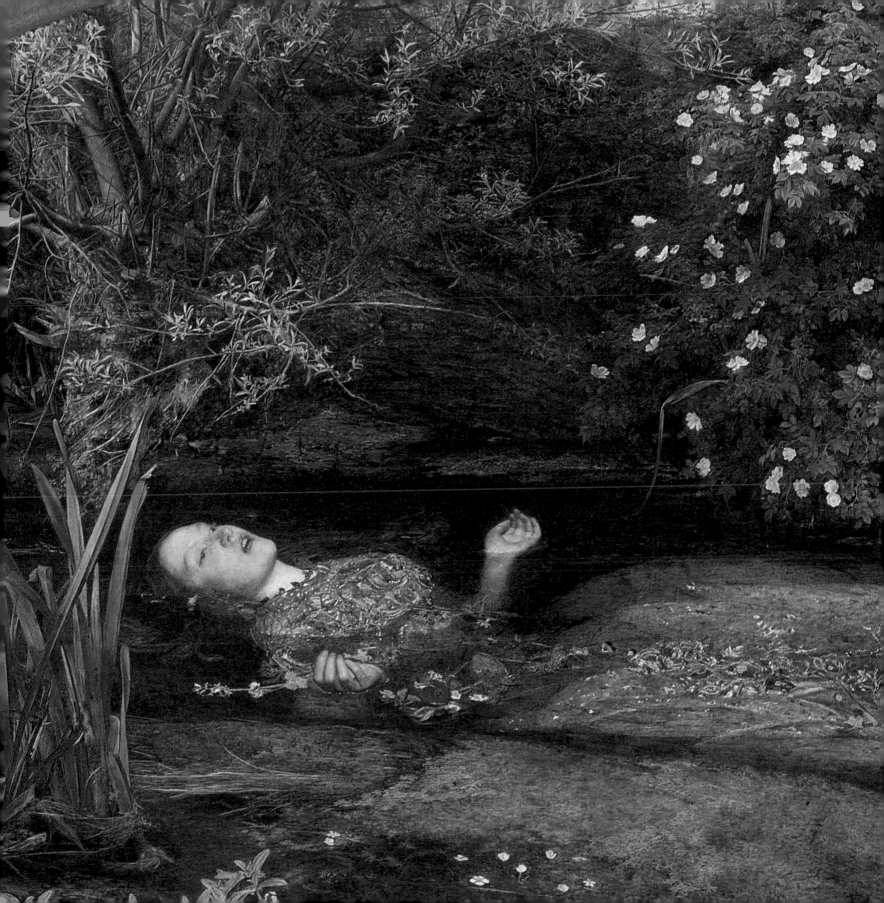

coarsenesses — no interior secrecies; open as the sunshine that creates it; fine-finished on both sides, down to the extremist point of insertion on its narrow stalk; and robed in the purple of the Caesars.... the poppy is painted glass – and warms the wind like a blown ruby.

Ruskin was an artist. Wilfrid Blunt tells us that 'Ruskin looked at flowers with the eye of an artist' and 'drew flowers that he might come to know them better'. He said it was difficult to give the accuracy of attention necessary to see their beauty without drawing them. Ruskin was above all things an observer of nature. In *Elements of Drawing* again the importance of close observation is repeated when he says:

I am nearly convinced, – when once we see keenly enough, there is very little difficulty in drawing what we see. But, even supposing this difficulty be still great, I believe that – sight is a more important thing than the drawing – and I would rather teach drawing that my pupils might learn to love nature than teach looking at nature that they may learn to draw.

Today Ruskin is a very neglected writer mainly because many of his writings are so difficult to read and understand. As Kenneth Clark said: 'For almost fifty years, to read Ruskin was accepted as proof of the possession of a soul. – Mention Ruskin in a popular bookshop and you will be offered books *about* him but never books *by* him'. This is understandable considering the complete and original version of *Modern Painters* runs to over 600,000 words. The following is from *Modern Painters*:

For their own sake, few people really care about flowers. Many, indeed, are fond of finding a new shape of blossom, caring for it as a child cares about a kaleidoscope. Many also like a fair service of flowers in the greenhouse, as a fair service of plate on the table. Many are scientifically interested in them, though even these in the nomenclature, rather than in the flowers. And a few enjoy their gardens; but I have never heard of a piece of land which would let well as a building lease remaining unlet because it was a flowery piece.

How similar these comments are to Morris's words in 1883:

I have lately seen Bournemouth, the watering place south west of the New Forest. It is a district (scarcely a town) of rich men's houses. There was every inducement there to make them decent, for the place, with its sandy hills and pine-trees, gave really a remarkable site. Well, there stand these rich men's houses among the pine trees and gardens, and not even the pine-trees and gardens can make them tolerable.

The term pre-Raphaelite needs some definition where William Morris is concerned. Morris and Burne-Jones are often called pre-Raphaelites, partly

27. Below *Arthur Hughes:* April Love, *1855 (London, Tate Gallery). Morris set his heart on this painting when he saw it exhibited at the Royal Academy.*

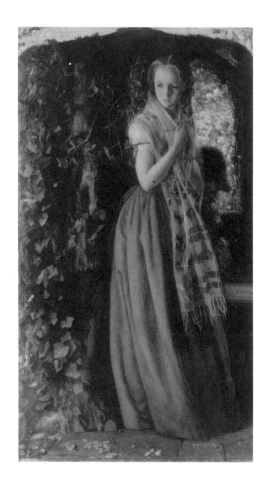

because of their close friendships with some members of the Brotherhood, particularly Dante Gabriel Rossetti, and also because, broadly speaking, they shared similar views on art. Some might say they were pre-Raphaelites but they were certainly never members of the Pre-Raphaelite Brotherhood – the famous PRB. Morris was only fourteen years old when the Brotherhood was founded in 1848 and by the time he went to Oxford the PRB had more or less broken up. However as the PRB went separate ways there emerged a second 'pre-Raphaelite' group centred first around Rossetti then later around Morris. From 1853 until 1856 Morris, Burne-Jones and their friends were little more than pre-Raphaelite enthusiasts. It was not until the meeting with Rossetti in the spring of 1856 that there was the beginning of a Morris/Rossetti/Burne-Jones 'circle'.

What was the common ground between the two groups? Originally Morris had been sympathetic to the PRB's treatment and approach to nature in art, but later Morris explained he understood that the importance of the Pre-Raphaelites was to startle people out of an art lethargy. The more important links between the circles were first the teaching and encouragement of John Ruskin and then the influence and personality of Dante Gabriel Rossetti.

Morris's enthusiasm for the style of pre-Raphaelite painting is best illustrated by his message to Edward Burne-Jones in London. Morris was financially well off while at university and often bought books and items of art without hardship. Struck by a picture he had seen at the 1856 Royal Academy exhibition he said to Burne-Jones on 17 May 1856: 'Will you do me a great favour, viz. go and nobble that picture called 'April Love' as soon as possible lest anybody else should buy it'. On 20 May Burne-Jones bought the painting for thirty pounds.

It is likely Morris saw Van Eyck's great altarpiece, in St Bavo's church, on his first foreign visit with his sister Henrietta during the summer vacation from Oxford in 1854. Mackail says Morris always thought Van Eyck and Memling were 'absolute and unapproached masters of painting'. Dürer had also visited Ghent and seen the altarpiece in 1521 and said, 'It is a very deeply considered painting'. Morris was, at the time, an enthusiastic collector of copies of Dürer's engravings.

Sir Charles Eastlake, later President of the Royal Academy and Director of the National Gallery, visited the church in 1828. Rossetti and Holman Hunt had followed in 1849 five years before Morris, and after another visit to the Low Countries in the autumn of 1856, with G.E.Street, Morris used a version of Jan van Eyck's motto 'Als ich kan' (If I can).

On 21 July 1869 Jane and Morris went to see 'the Van Eyk' in Ghent *en route* to Bad Ems. In Ghent if one says one is going to see *the* Van Eyck it means the Ghent Altarpiece in St Bavo's church. Later, in 1884, Philip Webb on his way to Italy also went to see the altarpiece and wrote, 'November 13th. Ghent. Van Eyck's Adoration of the Lamb – – unmentionable! –' It is assumed this was a compliment.

So why so much interest in Jan van Eyck's altarpiece? There is, of course, the mystery of who actually painted the altarpiece, Jan or his brother Hubert, but putting that aside the paintings are among the most important and beautiful works of the fifteenth century. They are believed to be some of the earliest known oil paintings. The altarpiece, sometimes called 'The Adoration of the Lamb' is a polyptych and painted with twenty-four scenes on both front and reverse sides. The lower centre front panel is the Adoration scene and it is this panel which is of most interest to those with an interest in flower painting. The naturalistic detail is considerable and all figures, flowers, buildings and plants are identifiable. The range of flowers and fruits suggest this is not an earthly scene but paradise.

To Morris the altarpiece represented a wonderful example of the skills of the end of the period he most admired. The accuracy, the dedication of the artist, the whole ambience of the church and its art were perfect for Morris's eyes and mind.

28 and 29. Left (detail) and right The Adoration of the Lamb, *panel from the altarpiece completed around 1430 by Hubert and Jan van Eyck. In the fifteenth and sixteenth centuries religious paintings often featured symbolic flowers, but here they are painted with botanical accuracy. The panel features vines, pomegranates, rue, roses, figs, valerian, rose campion, wild strawberry, tansy, Solomon's seal, greater celandine, dandelion, daisy, lily of the valley, lady's smock, irises, Madonna lilies, and many trees.*

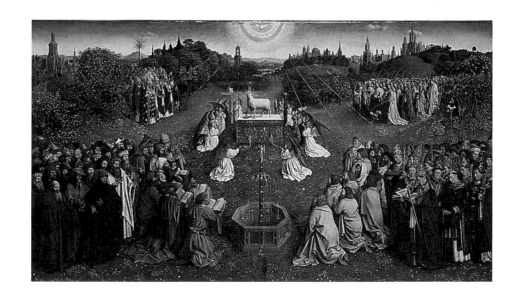

4. THE GARDENS OF WILLIAM MORRIS

Elm House, Woodford Hall and the Water House were the homes of Morris's parents but Red House, Horrington House, Kelmscott Manor and Kelmscott House were Morris's own homes for himself and his family. The early period at Queen Square has no garden interest but later the flowers and gardens at Merton Abbey Works were important to Morris.

Morris had originally bought an orchard and meadow at Bexley Heath, near the village of Upton in Kent, in the autumn of 1858, and decided to 'build the house in an orchard – with apple and cherry trees all around it'. The design was finished in April 1859 just before Jane and Morris were married. The countryside was 'fertile, well wooded and watered and interspersed with pleasant orchards and coppices', but the district 'was not one of any remarkable charm', according to Mackail. To Morris, however, it must have been something quite special being only 300 yards from the famous Dover Road along which Jerry Cruncher had driven his coach in the *Tale of Two Cities*.

Lady Burne-Jones described the site as being 'a roadside orchard surrounded by meadows and with space where they could build in the orchard with scarcely any disturbance of the trees'. The house took twelve months to build and was started in the summer of 1859. In the spring of 1860 Jane and Morris lived in Aberleigh Lodge, only 80 yards from the site and from there he could supervise progress. They moved into Red House, which cost £4000 to build, in June 1860.

Red House, where the 'Firm' (later Morris and Company) was conceived, is an important example of mid nineteenth-century domestic architecture and much has been written about it. It has been said the house was built 'as a revolt against the academic battle of the [architectural] styles' of the time. The book of the house, written by its present owner, Edward Hollamby, is recommended reading. There are very few surviving Morris papers from the Red House period. The best descriptions are from Lady Burne-Jones, J.W.Mackail and Aymer Vallance. There is also an estate agent's description in June 1866 when the house was put up for sale or rent.

The garden was a major feature of the house and was an integral part of

31. Left *Illustrations of Spring and Summer for a poem 'The Lapse of Time', from the 'Book of Verse' which Morris presented to Georgiana Burne-Jones in 1870. The illustrations are by Charles Fairfax-Murray based on sketches by Morris.*

32. Below *Elevation drawing of Red House by Philip Webb. The names of climbing plants for the walls are faintly pencilled in. The little square off to the side may be one of the gardens.*

Philip Webb's design. There are some near contemporary descriptions; Lady Burne-Jones tells us:

> *Many flowering creepers had been planted against the walls of the house from the earliest possible time, so that there was no look of raw newness about it; and the garden, beautified beforehand by the apple trees, quickly took shape. In front of the house [the garden] was spaced formally into four little square gardens making a big square together; each of the smaller squares had a wattled fence around it with an opening by which one entered, and all over the fence roses grew thickly. Where we sat and talked or looked out into the well-court two sides were formed by the house and the other two by a tall rose-trellis. The stable, with stalls for two horses, stood in one corner of the garden, end on to the road, and had a kind of younger-brother look with regard to the house.*

On Philip Webb's original drawings for the house (now in the Victoria and Albert Museum) can be seen pencilled notes where roses, white jasmine and passion flowers were to be planted against the north and west walls.

Mackail described the garden as follows:

> *The garden was planned with the same care and originality as the house;...But in his [Morris's] knowledge of gardening he did, and did with reason, pride himself. It is very doubtful whether he was ever seen with a spade in his hands; in later years at Kelmscott his manual work in the garden was almost limited to clipping his yew hedges. But of flowers and vegetables and fruit trees he knew all the ways and capabilities. Red House garden, with its long grass walks, its midsummer lilies and autumn sunflowers, its wattled rose trellises inclosing richly-flowered square garden plots, was then as unique as the house it surrounded. The building had been planned with such care that hardly a tree in the orchard had to be cut down; apples fell in at the windows as they stood open on hot autumn nights.*

33. Right *Red House, Bexley Heath. Morris lived at Red House for only five years and the plans for Burne-Jones and his family to join them there were never to come to fruition. When this became clear Morris wrote to Burne-Jones in 1864: 'As to our palace of Art, I confess your letter was a blow to me at first, – in short I cried; but I have got over it now'.*

Vallance quotes another account of the garden:

.... the surrounding garden divided into many squares, hedged by sweetbriar or wild rose, each enclosure with its own particular show of flowers; on this side a green alley with a bowling green, on that orchard walks amid gnarled old fruit trees; – all struck me as vividly picturesque and uniquely original.

Burne-Jones wrote, 'for the walls of other rooms than the drawing room at Red House Morris designed flower patterns, which his wife worked in wool on a dark ground, and it was a beautiful house', and in 1862 he said Morris 'is slowly making Red House the beautifullest place on earth'.

It is likely that the architectural novelty of the house with its poetic new owners together with their many merry friends encouraged exaggeration of the gothic and medieval character of the house and garden. While not all observers agree about the architectural significance of the house, all acknowledge its contribution to the art of the period.

Study of an 1860 Ordnance Survey map reveals some interesting details. The 'medievalism' of the garden is often mentioned but two of the four enclosed wattled gardens described by Georgiana Burne-Jones were in fact quite small, measuring 43 by 30 feet and 30 by 28 feet, each having a single 3 feet opening. The Red House site was approximately 300 feet deep by 175 feet wide and the bowling alley green to the west of the house was about 75 feet long and only 10 feet wide according to the 1860 map. There were also many varied walks in the orchards but it is unlikely these were very different from other typical Kentish orchard walks.

Philip Webb's pocket notebook for 12 November 1859 supports the measurements of the enclosed gardens at Red House when it gives the lengths of the wattle fencing purchased by him from Edward Russell of Bexley Heath. The fencing for the enclosed gardens totals 85 yards with a further 87 yards to enclose the rear garden around the well and the bowling green, with 13 yards left over for the kitchen garden. The total cost of 185 yards of fencing was £6-4s-6d at 8d per yard. Thirty shillings was paid in advance with the order.

Obviously Morris was keen to have some 'medieval' gardens and the enclosed plots were established for that purpose. However the rear garden and the bowling green alley were probably enclosed for a more practical reason, namely to provide shelter from the cold north east winds coming up from the Thames to the Heath.

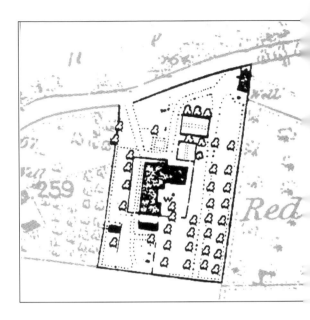

34. Above *An enhanced Ordnance Survey map of Red House in 1860. This map shows only forty trees. Philip Webb recorded eighty trees in his pocket notebook of November 1859, including at least thirty-three apple trees. The dotted lines show the footpaths. The bold thick line is the boundary wall or fence. The thin continuous lines show the positions of the wattle fencing recorded by Webb in the same notebook. The letter W indicates the well.*

The Webb notebook also shows how Morris was anxious to protect and preserve the fruit trees on the site they had so carefully chosen together. Webb lists eighty trees on the site during the building period, about seventy of these were fruit trees including, apples, pears, cherries, plums and damson. Several of the apples are trees with origins in the eighteenth century such as 'Ribston Pippin' (1707) and 'Blenheim Orange' (1740). It is thought 'Paradise' may go back to 1398 and came from Rouen, which would have pleased Morris. 'Winter Greening' and 'French Crab' were also originally from France. 'Flower of Kent' is said to come from the original stock in Isaac Newton's garden at Woolsthorpe Manor in 1629. It is interesting that the fruit trees were described as old and gnarled. Kentish orchards in the mid nineteenth century were depressed and suffering from cheap imported French apples. It may be that the orchard plot was bought cheaply because of the local depression.

After six and a half years of married life, and five and a half years in Bexley Heath, the Morris family left Red House in November 1865. Morris had intended it to be their permanent home and they had been happy there. 'Oh, how happy we were, Janey and I', said Burne-Jones's wife. Today Red House is still a wonderful house and is William Morris's legacy to all his admirers and supporters. It is the responsibility of all Morris enthusiasts to ensure this remarkable house is properly preserved for generations to come.

It is now an appropriate moment to consider *Trellis*, Morris's first design. *Trellis* was drawn in Morris's studio at Queen Square in November 1862. It is not thought to be his best design nor was it the first printed by the firm but it was certainly one of the most commercially successful. Most biographers repeat the story that *Trellis* was inspired by the rose trellises at Red House with very little supporting evidence. Even May Morris only half suggested this was so. It is possible that Morris used the roses as models but he was more likely to have turned to the many examples of trellis he had seen in medieval illustrations and works of art, rather than the garden flowers themselves.

The trellis was a frequently used motif in many fifteenth-century paintings and one in particular may have been the source for Morris's design. There are few details of the wedding of Morris to Jane Burden. May Morris reported that her mother and father went on honeymoon to France and Belgium and she also said they went 'on the Rhine to Basle, Liege, Namur, Mainz, Mannheim, Cologne, Ghent, Bruges, Antwerp, Brussels and had a fortnight in Paris'. It is most probable

35. Overleaf left Madonna in a Bower of Roses *by Martin Schongauer, 1473 (St Martin's, Colmar). Trelliswork is frequently seen in medieval art and Morris was probably also familiar with this altarpiece.*

36. Overleaf right *William Morris's original design for his* Trellis *wallpaper. This was drawn in Queen Square in 1862 (London, William Morris Gallery).*

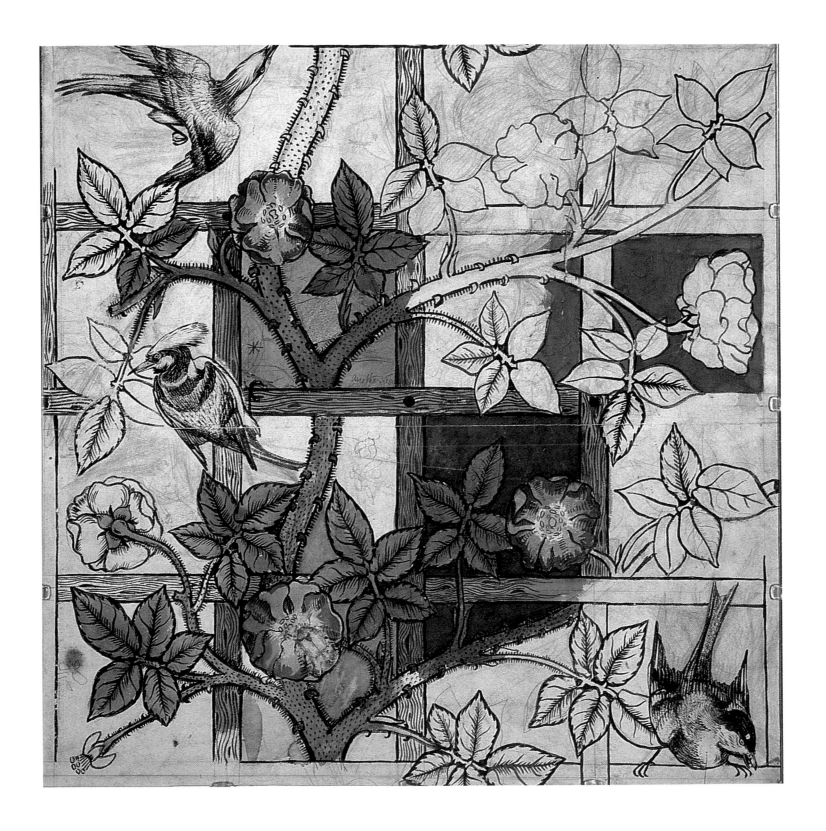

the honeymooners would have travelled by boat down the Rhine from Germany to Switzerland since the railways were in their infancy, and a boat would seem to be more appropriate for a honeymoon. Having travelled into this region it is highly likely they would have stopped over at Colmar, which is only eight miles from the Rhine, in order to visit St Martin's Church and see the famous altarpiece *Madonna in a Bower of Roses* painted by Martin Schongauer in 1473. In this picture the Virgin is seated in front of a trellised hedge full of wild and cultivated roses with some peonies. There are also birds in the hedge. Consider and compare the background of this picture with *Trellis* and the details of the birds by Philip Webb, the roses and the thorns. It is interesting also to note that Morris's first printed fabric design *Jasmine Trellis* (1868-70) was also based on a trellis design, although it was not the first commercially produced fabric.

On 17 May 1871 Morris wrote to his friend Charles Faulkner:

I have been looking for a house for the wife and kids, and whither do you guess my eye is turned now? Kelmscott, a little village about two miles above Radcott Bridge – a heaven on earth; an old stone Elizabethan house like Water Eaton, and such a garden!

After visiting the house on 20 May with Jane, Rossetti and Morris decided to rent the house and 68 acres of land jointly for £75 per year. Just a few weeks later in June they signed the lease. They were to share Kelmscott Manor until the summer of 1874. After 1874 Morris shared the lease with his publisher, Frederick Ellis, and although it was 'the house of his dreams' he never owned Kelmscott Manor.

Kelmscott Manor in Oxfordshire, built around 1570, was to become Morris's favourite house and home, particularly after Rossetti gave up his share and left. The village at that time had only 117 inhabitants. After Morris's death, Jane, his widow, continued to use the house, and bought it in 1913. His daughter,

37. Below *The frontispiece to* News from Nowhere, *Morris's utopian dream novel, showing the front of Kelmscott Manor with the rose lined path.*

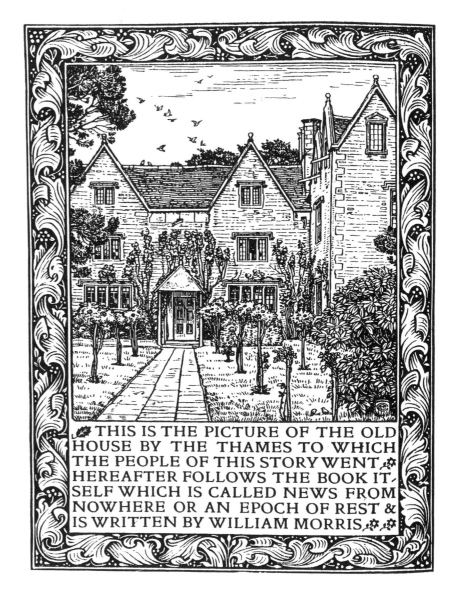

THIS IS THE PICTURE OF THE OLD HOUSE BY THE THAMES TO WHICH THE PEOPLE OF THIS STORY WENT HEREAFTER FOLLOWS THE BOOK IT SELF WHICH IS CALLED NEWS FROM NOWHERE OR AN EPOCH OF REST & IS WRITTEN BY WILLIAM MORRIS

May, inherited the property in 1914 and retained it until she died in 1938. Kelmscott Manor is now owned and managed by the Society of Antiquaries.

Morris's feelings about the manor garden are revealed in a February letter:

As to the garden, they are late here; there are two or three crocuses out, but most of them are not above ground even; the winter aconite is not fully in blossom, and the yellow jasmine is over. Snowdrops are everywhere, but mostly double, however they give one a delightful idea of spring about: there are a few violets out and here and there a coloured primrose; and some of the hepatica roots have flowered, but show no leaves. But how pretty it looks to see the promise of things pushing up through the clean un-sooty soil. I think we shall have a beautiful garden this year.

Seven weeks after signing the lease, on 9 July 1871, Morris departed for Iceland and did not return until 6 September. In a letter to his daughters on 16 July from Reykjavik he described the flowers he had seen in Iceland:

I send you some wild thyme I plucked this morning in the fields close by here; there are many pretty flowers about, but no trees at all; not even a bush about here, but the mountains are very beautiful.

Later that year he described more Icelandic flowers:

Sometimes though we would ride all day in the wastes; nothing with grey & black lava and sand, dotted over with tufts of sea pink and Campion, and the grey roots of dwarf willow; the distant hills dark inky purple on a dull day; or blue from indigo to ultramarine on a sunny one.

Back from his travels the following winter, Morris wrote to Georgie Burne-Jones's sister, Louisa Macdonald Baldwin from Kelmscott on 13 February 1872:

I have come down here for a fortnight to see spring begin; a sight I have seen little of for years, and am writing among the grey gables and rook haunted trees, with a sense of the place being almost too beautiful to work in:... I don't know how many tulips there won't be when they come into blossom.

In letters to Jane in the spring and summer of 1876 Morris again showed his feelings for Kelmscott.

It is a most beautiful afternoon: there are violets out, and (the sn) acconites, and the snowdrops are showing all about....

The garden has suffered here much from the cold & wet, I mean to say as to vegetable, for it looks beautiful: the strawberry bed is a mass of blossoms; there are no roses

38. Above *Detail of an Ordnance Survey map of Kelmscott Manor and its surrounds at about the time that Morris leased the manor. The map shows the close proximity of the house to the main river and the nearby streams.*

out except the yellow ones on the gable wall of the barn: but a fortnight hence, it will be a wonder for the roses: I must try to get down if only for a day at a time.

That summer in 1876 the illness, epilepsy, that was to afflict his elder daughter Jenny for the rest of her life made itself known. The family were devastated by the diagnosis. Some years before on 20 July 1873 Jenny had fallen into the water by the boathouse at Kelmscott and it has been suggested that this incident could have brought on the beginning of her, possibly inherited, health problems.

Study of Morris's letters to his daughters shows he used a different style of writing for each daughter. First his letters to May are fewer because, simply, he was often in her company. The more descriptive letters are always to Jenny who was often apart from her father. Morris was frequently away in Leek, experimenting with dyeing techniques with Thomas Wardle. On one trip he wrote to Jenny at Kelmscott:

Haddon is the most beautiful of the places about here....There are not many flowers out in the garden here: the tulips are over & the roses not yet come except one or two of yellow roses, that smell heavenly.

The garden at Haddon Hall was regarded as a good example of a well arranged old English garden which Morris applauded in some of his lectures.

Towards the end of his life, in October 1895, he described the garden at Kelmscott as having clipped hedges, including one he called 'Fafnir' after Sigurd's dragon. He also said that the garden looked like part of the house, 'yet at least the clothes of it', which should always be the aim of a garden:

Many a good house both old and new is marred by the vulgarity and stupidity of its garden, so that one is tormented by having to abstract in one's mind the good building from the nightmare of 'horticulture' which surrounds it.

40. Right *Kelmscott Manor in a recent photograph showing the new standard roses now planted along the path.*

39. Below *Watercolour by May Morris of Kelmscott Manor. This painting is now at Wightwick Manor, a house decorated by Morris and Company and now owned by the National Trust.*

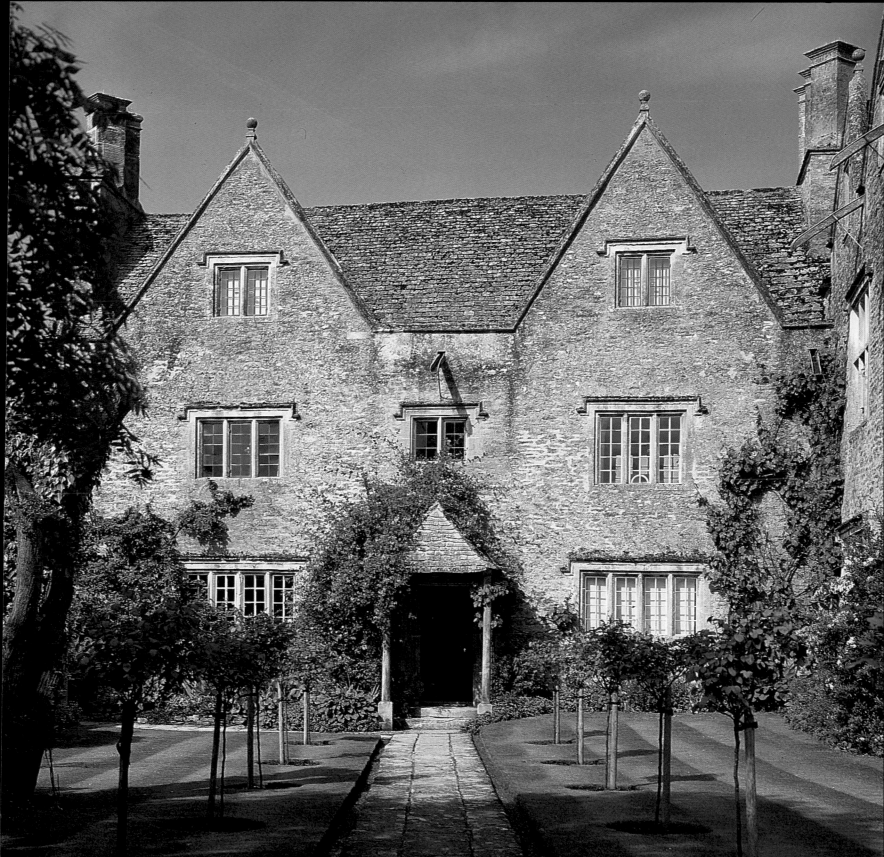

The following letter was written when he was staying at Kelmscott.

Dearest own Jenny, August 24, 1888

Altogether a very pleasant river to travel on, the bank being still very beautiful with flowers; the long-purples [loosestrife] *& willow herb* [great willowherb], *and that strong-coloured yellow flower very close & buttony* [tansy? fleabane?] *are the great show: but there* [is] *a very pretty dark blue flower, I think mug-wort* [figwort?], *mixed with all that besides the purple blossom of the horse mint & mouse-ear & here and there a bit of meadow sweet belated....*

As for flowers the July glory has departed, as needs must; but the garden looks pleasant though not very flowery. Those Sweet Sultans [centaurea moschata] *are run very much to leaf, but the beds in which they and the Scabious are look very pretty, the latter having a very delicate foliage. There are too tall hollyhocks (O so tall) by the strawberries, one white, one a very pretty red: there are still a good many poppies in blossom; a bed of*

41. Above *Photograph of Kelmscott Manor taken in the 1930s. May Morris owned the house until her death in 1938.*

42. Right *At Kelmscott Manor there was a topiary hedge at the rear of the house affectionately known to the family as 'Fafnir', the dragon of Sigurd the Volsung from the Icelandic saga Volsunga and the story of the Nibelungen. Morris felt that his Sigurd the Volsung of 1876 was his best poetic work. This engraving of 1910 is by F. L. Griggs.*

Chainy-oysters [China asters] *and a good many scattered about; also a good few Dianthus Hedwiggii* [a variety of Chinese pink] *which look very pretty: few apple few plums, plenty of vegetables else....*

 Your loving father William Morris.

 But Morris's deep feeling for Kelmscott Manor, the garden, and the nearby river, were never better described by him than in *News from Nowhere*, his utopian dream novel written in parts for *Commonweal* throughout 1890. These extracts are from the closing chapters as the main characters approach 'Kelmscott Manor' by river at the end of their long journey by boat from London.

 At last we passed under another very ancient bridge; and through meadows bordered at first with huge elm trees mingled with sweet chestnut of younger but very elegant growth; and the meadows widened out so much that it seemed as if the trees must now be on the bents only, or about the houses, except for the growth of willows on the immediate banks;... Presently we saw before us a bank of elm trees, which told us of a house amidst them, though I looked in vain for the grey walls that I expected to see there. We crossed the road,... and we stood on a stone path which led up to the old house.... My companion gave a sigh of pleased surprise and enjoyment; nor did I wonder, for the garden between the wall and the house was redolent of the June flowers, and the roses were rolling over one another with that

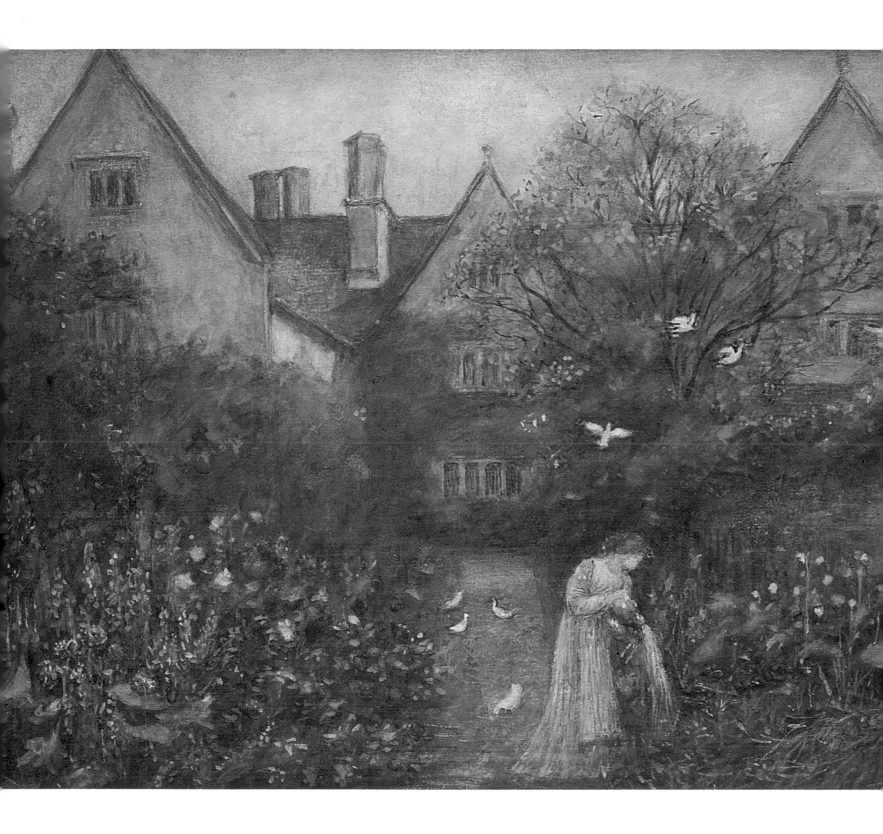

delicious super-abundance of small well-tended gardens which at first sight takes away all thought from the beholder save that of beauty. The blackbirds were singing their loudest, the doves were cooing on the roof ridge, the rooks in the high elm trees beyond were garrulous among the young leaves, and the swifts wheeled whining about the gables. And the house itself was a fit guardian for all the beauty of this heart of a summer.

In May 1896, five months before he died, Morris wrote to Lady Burne-Jones from Kelmscott: 'I have enjoyed the garden very much, and should never be bored by walking about and about in it.... The thing that was the pleasingest surprise was the raspberry-canes, which Giles has trellised up neatly, so that they look like a medieval garden'. It was the last time he saw his beloved Kelmscott house and garden.

Today Kelmscott Manor is in the care of the Society of Antiquaries and much thought and effort is being given to the replanting of the three gardens at the rear of the house. These are now known as Orchard, Lawn and Mulberry (with the 400 year old mulberry tree) and are as shown on the 1876 Ordnance Survey map. Although the newly laid gardens will not be exactly as Morris knew them, it is planned to stock them with appropriate plants and flowers. In Morris's words in 'Making the best of it':

It should look both orderly and rich. It should be well fenced from the outside world. It should by no means imitate either the wilfulness or the wildness of Nature, but should look like a thing never to be seen except near a house.

The Morrises lived at 26 Queen Square for seven years, but as the space requirements of the firm became more demanding the family moved again. In October 1872 Morris and Burne-Jones went house hunting in the Hammersmith area and Jane joined them in this task in late November when she returned from staying at Kelmscott Manor with Rossetti and the children. The final choice of property was not in Hammersmith but just over a mile to the west in the village of Turnham Green to a 'house on the Turnham Green Road' (now Chiswick High Street) and half an hour's walk to the Burne-Joneses at Fulham. Of this house, Horrington House, little is known. A pub called until recently the Roebuck stands on the site today. Morris described it as 'a *very* little house with a pretty garden'. Jane's opinion was somewhat less enthusiastic: 'a very good sort of house for one person to live in, or perhaps two'. They lived there for nearly six years.

In October 1878 the family moved for the last time. The choice of homes, the house hunting and decision making were Morris's. Jane seems not to have

Don't be swindled out of that wonder of beauty, a single snowdrop; there is no gain and plenty of loss in the double one. More loss still in the double sunflower, which is a coarse-coloured and dull plant, whereas the single one, though a late comer to our gardens, is by no means to be despised, since it will grow anywhere, and is both interesting and beautiful, with its sharply chiselled yellow florets relieved by the quaintly patterned sad-coloured centre clogged with honey and beset with bees and butterflies.

'Making the best of it', 1880

been very involved in the search for their new home. Of course, he was always concerned about the location of his homes *vis à vis* the firm. Commuting was again a consideration but from Kelmscott House this would now be fairly straight-forward with the availability of the Metropolitan Railway which had been operational from Shaftesbury Road station (renamed Ravenscourt Park in 1885) since June 1877. The underground trains were steam powered until 1905. It is clear from letters that Morris, while considering these domestic changes, was anxious that Jane should be happy, or at least acquiescent, with his choice. Other more fashionable districts were considered: Bloomsbury, Earls Court, St John's Wood and Regent's Park.

In March 1878 Morris told Jane that he has been to 'The Retreat' (later renamed Kelmscott House, after Kelmscott Manor), and said, 'We should do very well there'. He gave her a preliminary description of the house,

The garden is very long & good: it also has a drawback – of being overlooked badly down one half of it, because the wall lowers there: [later described by Morris as 'those bloody new houses'] *but we might stick up a great high trellis wh: would effectively shut out the overlookers: on the other side there are other gardens & all is quite pretty. If the matter lay with me only I should set about taking the house.*

On 18 March he wrote again, 'This letter is all about house-hunting; you must forgive me about troubling you about it; but I do not like the idea of leaving all to be done after you come home'. Jane was not happy with the idea. It seems Rossetti, who had visited the house, was giving her adverse reports, to which Morris said, 'I can't help thinking that your information – is grossly exaggerated'. In this letter Morris tried hard to convince Jane all was fine with the house:

The garden is most beautiful.... there is a real green-house down the garden, if you care for that, and capital stabling & coach house.... The situation is certainly the prettiest in London: you may mock at this among the olives beside the Midland Sea but to us poor devils of Londoners 'tis something: now my dear, you must settle whether I am to go further in this matter; as though 'tis certain that I am enclined to it I would not think of it again if you feel you would not like it.... I am dreadfully anxious about you.

As she was still not convinced, a few days later he sent her a very detailed description of the house and garden.

There is a good garden & root house, besides the large green house. a tank in the former for watering purposes: there are 2 arbours: there are of big trees 1st a walnut by the

stable: 2nd a very fine tulip tree halfway down the lawn. 3rd. 2 horse chestnuts at the end of the lawn: beyond that is a sort of orchard (many good fruit trees in it) with rough grass (gravel walk all round garden): then comes the green-house & beyond that a kitchen: garden with lots of raspberries. This is the plan of garden –

47. Right *Tulip and Willow*, original design for printed linen by William Morris, 1873 (Birmingham Museums and Art Gallery). Wild tulips were among the richest of blossomings at Kelmscott Manor. Late in her life May Morris remembered how interested she had been when her father explained the botanical details of flowers and the variety in the willow leaves, and how she afterwards looked at Gerard's herbal with him.

45. Left *Plan of the garden at Kelmscott House drawn by Morris in a letter to Jane who was on holiday in Italy at the time. He later wrote, 'Let us hope we shall all grow younger there, my dear'.*

46. Below *Wood engraving of willow in Gerard's herbal.*

This is pretty accurate as to proportions: only the orchard is rather longer than I have drawn it & the kitchen garden not so long: the walls are covered with fruit trees: Margery [Burne-Jones's daughter?] says the raspberries were very good & many there: the lawn is in good condition: sweet grass & not mossy.

On 2 April Morris told Jane he had agreed to take the house and with feeling wrote,

I do think that people will come to see us at the Retreat (fy on the name!) if only for the sake of the garden and river: we will lay ourselves more for company than heretofore. You must remember also that 'tis much nearer to the Grange; – So let us hope we shall all grow younger there, my dear.

Finally Jane agreed and the family moved to their new home by the river at the end of October 1878.

During 1879 the firm's carpet making activities were moved into the coach house at Kelmscott House. In April Morris delivered his important lecture 'The history of pattern designing' to the Trades Guild of Learning.

Morris settled down well at Kelmscott House. So much so that he wrote to Georgie Burne-Jones, 'Somehow I feel as if there must soon be an end for me playing at living in the country: a town-bird I am, a master artisan, if I may claim that latter dignity'. Kelmscott House was, however, no match for Kelmscott Manor in his affections and it is to the Oxford house the family goes for Christmas in 1879. May Morris said Morris never felt in his heart that the London house was their real home. It was a convenient temporary abode. In contrast, going to Kelmscott Manor was 'coming home'.

The garden at Kelmscott House was a strong feature in the case Morris put to Jane for buying the house. In his letters he later often described the garden to Jane, Jenny and May when they were apart. When Jane was on holiday in Italy he wrote:

I have just come in from the garden, which is really looking nice now; the seeds mostly in, & the daffodils almost out in blossom: I am sorry to say though the frost killed almost out all the wall-flowers: poor old Matthews is very slow; but I don't like sacking him: even on selfish grounds, a new system of horticulture will be more than the garden or I can stand.

The idea of his two 'Kelmscott' houses being linked by the River Thames was a further delight for Morris, and in the summers of 1880 and 1881 the family and friends embarked aboard the Ark for the long, but wonderful, journey by river from Kelmscott House to Kelmscott Manor. On their return Morris prepared his lecture to the Working Men's College 'Some hints on pattern designing'.

In April 1882 Rossetti died. Morris's feelings were very mixed at this news. He thought of the coming spring and summer and wrote to Jenny:

The garden to my cockney eyes is looking pretty well, though I daresay you would think Pig-End somewhat dreary; but the new little trees look pretty there and are coming out into bud: I am dissapointed with the daffies: many of them are blind, some will be quite out in a day or two.

Pig-End was the corner of the garden where leaf-mould and manure were kept and Morris said he regretted there was no pig. Then again to Jenny:

Both the Hammersmith & the Merton gardens are looking very nice now, though

48. Right *Photograph of Jane Morris in the garden at Kelmscott House in 1884. During Morris's time the garden extended from the river almost to the Hammersmith High Road (now King's Street). The planting of the borders here is very reminiscent of the style recommended by William Robinson. Pinks and poppies are easy to pick out and there are certainly none of Morris's abhorred scarlet geraniums or yellow calceolarias.*

even the latter is commonplace compared with Kelmscott. A lady who came on Thursday with Mrs Rodney Isabellas friend sent us yesterday a lot of peonies, single ones of various kinds very handsome: they are chinese flowers & look just like the flowers on their embroideries.... [and in the autumn] *The garden here is going the way of all London autumn gardens; but there is still a sort of pale prettinesss about it, and there are a good many flowers, in it cheifly Japonese anemones and 'Chaynee oysters'. The gardener is busy today tidying up.*

Morris died at Kelmscott House on 3 October 1896.

With town house gardens uppermost in his mind in one of his early lectures in 1880 'Making the best of it' Morris had told his audience he wanted to make people 'think about their homes, to take the trouble to turn them into dwellings fit for people free in mind and body'....

Before we go inside our house, nay, before we look at its outside, we may consider its garden, chiefly with reference to town gardening, which, indeed I, in common, I suppose, with most others who have tried it, have found uphill work enough – All the more as... few indeed have any mercy upon the one thing necessary for decent life in a town, its trees, till we have come to this, that one trembles at the very sound of an axe as one sits at one's work at

home. However, uphill work or not, the town garden must not be neglected if we are to be in earnest in making the best of it.

Now I am bound to say town gardeners generally do rather the reverse of that; our suburban gardeners in London, for instance, oftenest wind about their little bit of gravel walk and grass plot in ridiculous imitation of an ugly big garden of the landscape gardening style, and then with a strange perversity fill up the spaces with the most formal plants they can get; whereas the merest common sense should have taught them to lay out their morsel of ground in the simplest way, to fence it as orderly as might be, one part from the other (if it be big enough for that) and the whole from the road, and then to fill up the flower-growing space with things that are free and interesting in their growth, leaving Nature to do the desired complexity, which she will certainly not fail to do if we do not desert her for the florist, who, I must say, has made it harder work than it should be to get the best of flowers.

It is scarcely a digression to note his way of dealing with flowers.... note the way he has treated the rose, for instance: the rose has been grown double from I don't know when; the double rose was a gain to the world, a new beauty was given us by it, and nothing taken away, since the wild rose grows in every hedge.

Gertrude Jekyll (1843-1932), called to meet Morris at Queen Square in about 1865. He was nine years older than the later to be famous gardener, who was then a student at South Kensington School of Design studying under Richard Redgrave, mastermind of the flower drawing curriculum for 'Mr Gradgrind' himself – Henry Cole. Christopher Dresser was then Professor of Botany at the school together with Owen Jones author of the *Grammar of Ornament*.

Gertrude Jekyll later became a disciple of William Robinson (1838-1935), author of the well known nineteenth-century gardening books *The Wild Garden* (1871, illustrated by Alfred Parsons, a founder member of the Art Workers Guild), and *The English Flower Garden* (1883). When he writes about the summer garden in *The English Flower Garden* Robinson reveals Morris's influence on him and their shared views on the horror of the fashion for carpet bedding. He quotes Morris:

Another thing also much too commonly seen, is an aberration of the human mind, which otherwise I should have been ashamed to warn you of. It is technically called carpet-gardening. Need I explain it further? I had rather not, for when I think of it, even when I am quite alone, I blush with shame at the thought.

Gertrude Jeykll owned a painting by Rossetti and was an admirer of Ruskin and the pre-Raphaelites. She was an acquaintance of Philip Webb and on

49. **Right** *Rose, an original design by William Morris for cotton and linen, 1883. In this design the many roses interplay with a few eastern tulips with some five-petalled potentilla peeping through scarcely noticed. Like the famous* **Trellis** *design,* **Rose** *includes a number of birds which again were possibly drawn by Philip Webb.*

Morris must have been the first to champion the old-fashioned rose. In 'Making the best of it' he wrote:

The garden-rose had a new beauty of abundant form, while its leaves had not lost the wonderfully delicate texture of the wild one. The full colour it had gained, from the blush-rose to the damask, was pure and true amidst all its added force, and though its scent had certainly lost some of the sweetness of the eglantine, it was fresh still, as well as so abundantly rich. Well, all that lasted till quite our own day, when the florists fell upon the rose.... They missed the very essence of the rose's being; they thought there was nothing in it but redundance and luxury; they exaggerated these into coarseness, while they threw away the exquisite subtlety of form, delicacy of texture, and sweetness of colour, which, blent with the richness which the true garden-rose shares with many other flowers, yet makes it the queen of them all – the flower of flowers.

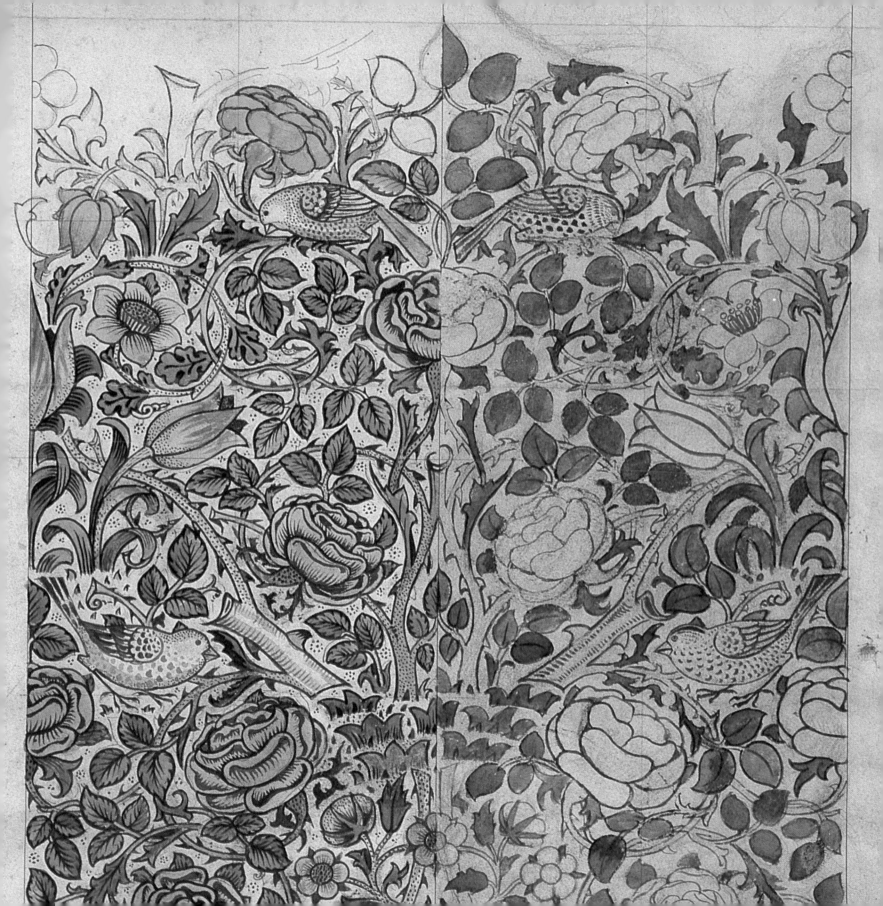

one occasion recommended a good well-digger to him. Until she developed eye trouble in 1891 she was determined to be a craftswoman and designer. When she became a gardener she pressed for the link between a house and its garden as described by Morris in his lecture 'Making the best of it' in 1880 and as further promoted by Robinson.

Arts and Crafts principles, as encouraged by Ruskin and Morris, had their effect on gardeners and gardens. But as always there were differences of opinion within gardening circles, mainly between the architect gardeners and the practical gardeners. John Dando Sedding and Reginald Blomfield, both leading members of the Art Workers Guild, advocated a return to a more old fashioned formal garden while still remembering Morris's principles.

As the firm expanded it became necessary to move out of central London. The final choice of site took Morris some time, the most serious requirement being a good water supply for the production of the printed fabrics. Historically textile printing was concentrated in three areas of greater London, on the rivers Lea, Cray and Wandle. After much consideration Morris chose the Wandle. He had been tempted to set up his expanding works in some rural setting such as Gloucestershire but reluctantly abandoned the idea. He said he felt that as a Londoner he ought to be loyal to London and do the best by her. The fact of the matter was that London was a more practical choice.

Merton Abbey Works was not a home but a workplace. But Morris wanted to demonstrate that pleasant surroundings at work would not be 'in any way fatal to the success of the business as a matter of ordinary commerce'. He described a better approach to the production environment in his article in *Justice* in 1884, 'A factory as it might be', in which he promotes better facilities even advocating factory gardens, something only a few firms consider worthwhile today. On another occasion he said:

It is right and necessary that all men should have work to do: First, Work worth doing; Second, Work of itself pleasant to do; Third, Work done under such conditions as would make it neither over-wearisome nor over anxious. – The second necessity is decency of surroundings.

Morris signed the lease for the Merton factory buildings and land on 7 June 1881. One of the first things he did was to plant poplars round the meadow where the calico prints were to be laid. Mackail says:

The works stood on seven acres of ground, including a large meadow as well as an orchard and vegetable garden. The riverside and the mill pond are thickly set with willows and large poplars; behind the dwelling house a flower garden, then neglected, but soon restored to beauty when it came into Morris's hands, runs down to the water.... Beyond the meadow are the remains of a medieval wall, the sole remaining fragment of Merton Abbey.

An entry in a visitor's diary in April 1882 read, so Mackail tells us:

To Merton Abbey – white hawthorn was out in the garden: we had tea with Mr Morris in his room in the house, and left laden with marsh marigolds, wallflowers, lilac, and hawthorn.

In February 1883 Morris wrote to Jenny, 'At Merton there are some [daffodils] out already: the almond tree is blossoming there beautifully', and a few weeks later he wrote to her again:

I have been to Merton today, and after a morning shower it turned out so beautiful!. I had a pleasant day on the whole things going on fairly: the marsh marigolds are all out & are splendid; one clump by the tailside (of the waterwheel) is a picture.... I hope to present you with a tolerable suburban garden when you come up: the apple trees are nearly in full blossom: at Merton, by the way, they are lovely: I got my first bundle of sparrow-grass [asparagus] there today, but I thought it too small to send to you:... My deary Jenny, goodbye; did you like the flowers I sent you from Axminster by the way? I will pick a big bunch of wall-flowers tomorrow & send them to you somehow.... Merton is looking very pretty now, the hawthorn just coming out; but scarce any lilac there is one pretty blossom-tree which is new to me so with white blossoms something like the Portugal laurel blossoms: Edgar [Morris's brother] says it is the Dog-wood, but I can't find it in Gerard.

Mackail says that in 1899, even after Morris's death, the works at Merton seemed to be an escape from the real world.

As one turns out of the dusty high road and passes through the manager's little house, the world seems left in a moment behind. The old-fashioned garden is gay with irises and daffodils in spring, with hollyhocks and sunflowers in autumn, and full, summer by

50. Left *Printing chintzes at the Merton Abbey Works. Morris opened the Works in 1881. It was here Morris and Company produced most of the block printed chintzes. It is often overlooked that Morris and Company never manufactured wallpapers in-house unlike the fabrics, carpets and stained glass. All wallpaper printing was contracted out to Jeffrey & Co. at Islington.*

summer, of the fragrant flowering shrubs that make a London suburb into a brief June Paradise. It rambles away towards the mill pond with its fringe of tall poplars; the cottons lie bleaching on grass thickly set with buttercups; little stream running between them, and the wooden outside staircases leading to their upper story, have nothing about them to suggest the modern factory; even upon the great sunk dye-vats the sun flickers through leaves, and trout leap outside the windows of the long cheerful room where the carpet-looms are built....

Of these flowers, and of others in their seasons, Morris often used to bring back bunches to London with him, and wonder why any one should be laughed at – as in London one then still was – for carrying flowers.

Morris and Company continued to manufacture on the site until 1940.

51. Above *Painting of the pond at Merton by Lexden Lewis Pocock, 1924 (London, Victoria and Albert Museum), showing the very pleasant surroundings at Merton Abbey Works on the Wandle. Morris said, 'some of these fine days the place has looked pretty, the water sparkling among the twigs.'*

52. Right Wandle, *design on cotton by William Morris, 1884. May Morris said most wallpapers and fabrics were named after 'its [own] bit of story'.* **Wandle** *was fitly named to honour 'the little stream sparkling among the greenery about the wooden workshops within the ancient Abbey building'.*

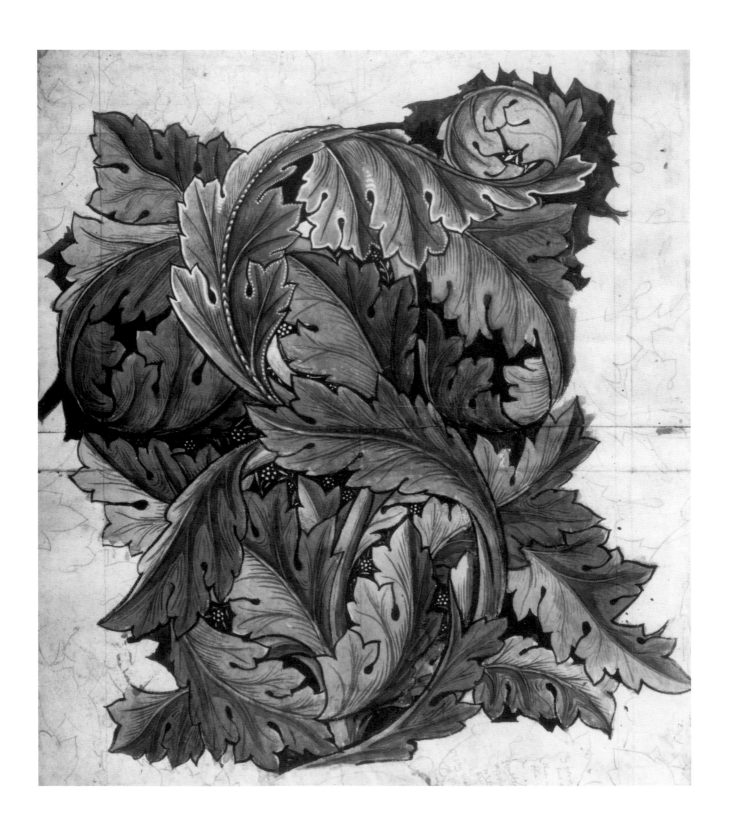

5. FLOWERS IN THE MAKING OF PATTERNS

At the beginning of the nineteenth century, ornamentation of manufactured goods in Britain was still influenced by the French following a post Revolutionary export drive by French manufacturers. They had mounted the world's first industrial exhibition in 1798 and the effects of this caused concern in Britain. In 1836 a Select Committee enquiry led to the setting up of the Government School of Design in 1842 with its emphasis on botanical drawing.

In and around the 1840s floral printed designs with a strong naturalistic look were popular, but over the next two decades, partly under the influence of Pugin and Owen-Jones, public taste moved towards design themes of a more abstract nature. Therefore when Morris put his *Trellis*, *Daisy* and *Fruit* wallpapers on the market between 1864 and 1866 he was not thought to be setting a trend since naturalistic designs were out of fashion. Nevertheless Morris's first designs were and still are very popular and commercially attractive. There is something indefinably different about a Morris design. Even within Morris and Company it is usually not difficult to identify Morris's own designs from those of his friends and employees.

John Dando Sedding wrote: 'We should have had no Morris, no Street, no Burges, no Shaw, no Webb, no Bodley, no Rossetti, no Burne-Jones, no Crane but for Pugin'. Sedding, like Pugin, was an enthusiastic Catholic, architect and gardener, supporter of Morris and author of *Garden Craft – Old and New* (1891). Morris was only fifteen when Pugin, in his book *Floriated Ornamentation* (1849), had written:

I became fully convinced that the finest foliage work in the Gothic buildings were all close approximations of nature, and that their peculiar character was chiefly owing to their arrangement and disposition. During the same journey I picked up a leaf of dried thistle from a foreign ship unloading at Harve and I have never seen a more beautiful specimen of what we should visually term Gothic foliage: The extremities of the leaves turned over so as to produce the alternate interior and exterior fibres, exactly as they are worked in carved panels of the 15th C, or depicted in illuminated borders. The more carefully I examined the productions of the medieval artists, in glass painting, decorative sculpture, or metalwork, the more fully I

53. Left *Acanthus, drawing for wallpaper by William Morris, 1875 (London, Victoria and Albert Museum). Morris used the name 'Acanthus' on several designs: first a wallpaper in 1875; a printed cotton velveteen in 1876; a woven silk damask, a cotton and silk and a woollen damask in 1879. All three were wholly different designs. The acanthus is the most widely used motif in classical ornamentation, originating from the Mediterranean plant Acanthus spinosa. The leaf was so popular in architectural ornamentation that a series of booklets,* A Guide for drawing the Acanthus, *was published in 1840 by J. Page specially for designers, artisans and craftsmen.*

*was convinced of their close adherence to natural forms.... It is absurd to talk of **Gothic** foliage. The foliage is natural.... and it is the **adaptation & disposition** of it which stamps the style. The great difference between antient & modern artists in their adaptation of nature for decorative purposes is as follows. The former disposed the leaves & flowers of which their design was composed into geometrical forms & figures, carefully arranging the stems and component parts so as to **fill up** the space they were intended to enrich; and they were represented in such a manner as not to destroy the consistency of the peculiar feature or object they were employed to decorate, by merely imitative rotundity or shadow: for instance, a pannel, which by its very construction is flat, would be ornamented by leaves or flowers drawn out or extended, so as to display their geometrical forms on a flat surface, while, on the other hand, a modern painter would endeavour to give a fictitious idea of relief, as if **bunches** of flowers were laid on, and by dint of shadow and foreshortening....*

*Nature supplied the medieval artists with all their forms and ideas; the same inexhaustible source is open to us; and if we go to the **fountain head**, we shall produce a multitude of beautiful designs treated in the same spirit as the old, but new in form. We have the advantage of many important botanical discoveries which were unknown to our ancestors; and surely it is in accordance with the true principles of art, to avail ourselves of all that is beautiful for the composition of our designs. I trust, therefore, that this work may be the means of leading designers back to **first principles**;... It is impossible to improve on the works of God; and the natural outlines of leaves, flowers, etc must be more perfect and beautiful than any invention of Man. As I have stated above, the great skill of the antient artists was in the **adaptation** and **disposition** of their forms.*

55. Right *Design for **Honeysuckle** by William Morris, 1874 (Birmingham Museums and Art Gallery). According to May Morris the Honeysuckle design was originally for embroidery done at Kelmscott by her mother, Jane Morris. She wrote of the triumph of her father's technical skill in bringing the Crown Imperial, the poppy, the honeysuckle, the fritillary and yew twigs all together in this design. Morris grew the Crown Imperial at Kelmscott. 'Several of the Crown Imperials show for bloom; but are not done yet, nor are the yellow tulips'.*

54. Left *Design for an octagonal table by Augustus Welby Pugin (London, Victoria and Albert Museum).*

These were the principles Morris had in mind as he set about his floral designs. Morris presented hundreds of speeches, lectures, or talks between 1877 and 1896 and spoke many times on issues concerned with art, pattern designing, nature, conservation, work and leisure. In 'Making the best of it' (one of a series of papers published under the title *Hopes and Fears for Art* in 1880) and in 'Some hints on pattern designing' (1881), Morris spoke clearly about flowers and gardens.

He was concerned to encourage designers and craftsmen to offer quality products to the public. In 'Some hints on pattern designing' to the Working Men's College, Morris started by giving the audience, mainly artisans, his definition of pattern designing as the ornamentation of a surface by means not imitative or historical. He said it was advisable to surround ourselves with decoration, lesser art not fine art, originating from natural sources not from scientific representations:

...ornament that reminds us of the outward face of the earth – because scientific representation of them [flowers, animals *etc*] *would again involve us in the problems of hard fact and the troubles of life, and soon once more destroy our rest.*

He was anxious to point out that because this decoration was not fine art but secondary or lesser art there should be abundance of it for all to enjoy. He continued:

Of course you understand that it is impossible to imitate nature literally; the utmost realism of the most realistic painter falls a long way short of that;... If you are to put nothing on it but what strives to be a literal imitation of nature, all you can do is to have a few cut flowers or bits of boughs nailed to it, with perhaps a blue-bottle fly or a butterfly here and there. – Is it not better to be reminded, however simply, of the close vine-trellis that keeps out the sun by the Nile side; or of the wild-woods and their streams, with the dogs panting beside them; or of the swallows sweeping above the garden boughs toward the house-eaves where their nestlings are, while the sun breaks [through] *the clouds on them; or of the many-flowered summer meadows of Picardy? Is not all this better than having to count day after day a few sham-real boughs and flowers, casting sham-real shadows on your walls with little hint of anything beyond Covent Garden in them?... Ornamental pattern-work... must possess three qualities: beauty, imagination and order.... as to the third – order invents certain beautiful and natural forms, which will remind not only of nature but also of much that lies beyond that part.*

Morris then explained the fundamental structures of pattern design and went on to speak of art moving from Classical to Byzantine, what he called the

56. Right *Evenlode* (London, Victoria and Albert Museum), designed by William Morris for cotton 1883. This was the first design to be named as one of the 'River' designs. In this popular design Morris incorporates roses, dianthus, eastern tulips, daisy-sunflowers and another stylised bloom.

new-born Gothic art. At this time, he said, the change was to the continuous growth of curved lines taking the place of interlaced straight lines:

When young Gothic took the place of old Classic, the change was marked in pattern-designing by the universal acceptance of continuous growth as a necessity of borders and friezes; [it was] this invention of the continuous line that led to elaborate and independent pattern-work.

After explaining further the difficulties of pattern designing Morris amusingly warned his audience: 'You cannot well go wrong as long as you avoid [the] commonplace, and keep somewhat on the daylight side of nightmare'.

A good pattern must be surrounded by a line of another tint:

If this is well done, your pieces of colour will look gemlike and beautiful in themselves, your flowers will be due carpet-flowers, and the effect of the whole will be soft and pleasing. – I, as a Western man and a picture lover, must still insist on plenty of meaning in your patterns; I must have unmistakeable suggestions of gardens and fields, and strange trees, boughs, and tendrils, or I can't do with your pattern, but must take the first piece of nonsense-work a Kurdish shepherd has woven from tradition and memory; all the more, as even in that there will be some hint of past history.

Speaking of embroidery designing:

It is very apt to lead people into cheap and commonplace naturalism: now, indeed, it is a delightful idea to cover a piece of linen cloth with roses and jonquils and tulips, done quite natural with a needle, and we can't go too far in that direction if we only remember the needs of our material and the nature of our craft in general: these demand that our roses and the like, however unmistakably roses, shall be quaint and naive to the last degree, and we shall make the most of them, and not forget that we are gardening with silk and gold thread.

He warned those designing patterns:

Above all things, avoid vagueness;... Definite form bounded by firm outline is a necessity for all ornament.... do not be afraid of your design or try to muddle it up so that people can scarce see it; if it is arranged on good lines, and its details are beautiful, you need not fear its looking hard so long as it covers the ground well and is not wrong in colour.

Rational growth is necessary to all patterns, or at least the hint of such growth; and in recurring patterns, at least, the noblest are those where one thing grows visibly and necessarily from another. Take heed in this growth that each member of it be strong and crisp, that the lines do not get thready or flabby or too far from their stock to sprout firmly and vigorously; even where a line ends it should look as if it had plenty of capacity for more growth if so it would.

58. Right *Snakeshead printed cotton design by William Morris, 1876. The name derives from the snakeshead fritillary (Fritillaria melangris L.), a flower often featured in Morris's patterns and popular with botanical artists including John Ruskin and Rory McEwen. Gerard in his herbal called this flower Ginny Hen, Turkey Hen or the Chequered Daffodil (see plate 65). It grows in wet meadowlands, particularly in the Thames valley near Oxford. As often the title flower is not the most prominent motif in the design and the dominant flower here suggests the Greater knapweed (Centaurea scabiosa).*

57. Below *Mattioli's woodcut for Cynara cardunculus. The vigour of the drawing has a strong affinity with that by Morris.*

59 and 60. Above and right *Two designs by William Kilburn (London, Victoria and Albert Museum). In the late eighteenth century Kilburn worked as a calico print and wallpaper designer. His designs were usually in the French style and some of Morris's patterns have echoes of Kilburn in them. Kilburn was also responsible for many of the fine and botanically accurate coloured engraved drawings in* Curtis's Botanical Magazine *and in the* Flora Londonensis.

Again, as to dealing with nature. To take a natural spray of what not and torture it into certain lines, is a hopeless way of designing a pattern. In all good pattern-designs the idea comes first, as in all other designs, e.g., a man says, I will make a pattern which I will mean to give people an idea of a rose-hedge with the sun through it; and he sees it in such and such a way; then, and not till then, he sets forth to draw his flowers, his leaves and thorns, and so forth, and so carries out his idea.

In choosing natural forms be rather shy of certain very obvious decorative ones, e.g., bindweed, passion-flower, and the poorer forms of ivy, used without the natural copiousness. I should call these trouble savers, and warn you of them. unless you are going to take an extra amount of trouble over them. We have had them used so cheaply this long while that we are sick of them.

On the other hand, outlandishness is a snare. I have said that it was good and reasonable to ask for obviously natural flowers in embroidery; one might have said the same about all ornamental work, and further, that those natural forms which are at once most familiar and most delightful to us, as well from association as from beauty, are best for our purpose. The rose, the lily, the tulip, the oak, the vine, and all the herbs and trees that even we cockneys know about, they will serve our turn better than queer, outlandish, upsidedown-looking growths. If we cannot be original with these simple things, we shan't help ourselves out by the uncouth ones....

Don't copy any style at all, but make your own; yet you must study the history of our art... If I am speaking to any pattern-designers here... I would like to remind them of one thing, that the constant designing of recurring patterns is a very harrassing business.... A friend of mine, who is a Manchester calico-printer, told me the other day that the shifty and clever designers who draw the thousand and one ingenious and sometimes pretty patterns for garment-goods which Manchester buys of Paris, have a tendency to go mad, and often do so; and I cannot wonder at it.

The importance of herbals to Morris the artist cannot be overestimated. His interest was fourfold: first they were usually printed in or around his beloved sixteenth century; second they were full of the practical information he loved; third the illustrations were woodcuts or wood engravings of high quality; and last they were about plants. What more could he have asked from a book?

Herbals have a known history going back to the Greeks but there is little information about them until the writings of Pliny the Elder and Dioscorides. Morris says of Pliny 'a most curious book – altogether one of the most amusing books in the world to my mind'. Before the sixteenth century all such herbals were

in manuscript, sometimes with illustrations, but usually simply plain text. In Morris's extensive library there were several printed sixteenth-century herbals. Those most highly regarded and used by him were written, or compiled, by Leonhart Fuchs, Pierandrea Mattioli and John Gerard. Morris, in his writings, makes no reference to one other important sixteenth-century herbal, that by Otto Brunfels. This is surprising as it is the earliest of the four books and often regarded as the pioneer of the printed herbals. Blunt and Raphael in *The Illustrated Herbal* wonder whether Morris and Ruskin ever saw this book.

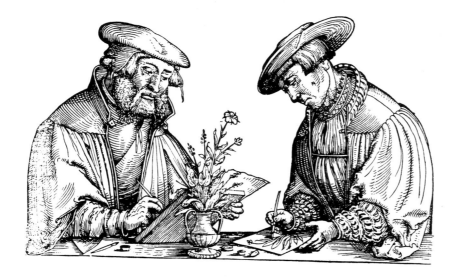

Between 1530 and 1536 Otto Brunfels published his *Herbarum Vivae Eicones* meaning 'Portraits of Living Plants'. This was followed in 1542 by *De Historia Stirpium* by Leonhart Fuchs, after whom the fuchsia is named (Mackail gives Morris's copy as 1543). In terms of quality, reproduction, and layout, Fuchs is better than Brunfels, although the latter was the pioneer with its illustrations by the artist Weiditz. Later in life Morris's favourite herbal was the Fuchs. In 1544 came the *Commentarii in sex Libros Pedacii Dioscorides* by Pierandrea Mattioli, or Mattiolus. Mattioli was born in Sienna. Although his illustrations cannot match those of Fuchs or Brunfels, they have a strong and energetic quality which may have been more appealing to Morris as a graphic designer than the more purely botanical drawings. Wilfred Blunt says Sydney Cockerell owned a copy of the Mattioli herbal; perhaps this was Morris's. What we do know is that there was a 1542 Fuchs in the sale of Morris's books at Sothebys in 1898.

61. Left *Leonhart Fuchs in the herbal* De Historia Stirpium *(1542) paid unusual tribute to his botanical draughtsmen and engraver by including their portraits in the book.*

64. Right *Daisy wallpaper by William Morris, 1862. There is a similarity between the simple floral elements of this design and daisy illustrations in the early herbals.*

62 and 63. Above and below *Two wood-block engravings of a columbine and a daisy from Gerard's herbal. According to Gerard, 'The daisies do mitigate all kinde of paines, but especially in the joints, and gout'. Morris began to suffer badly from gout in his middle years.*

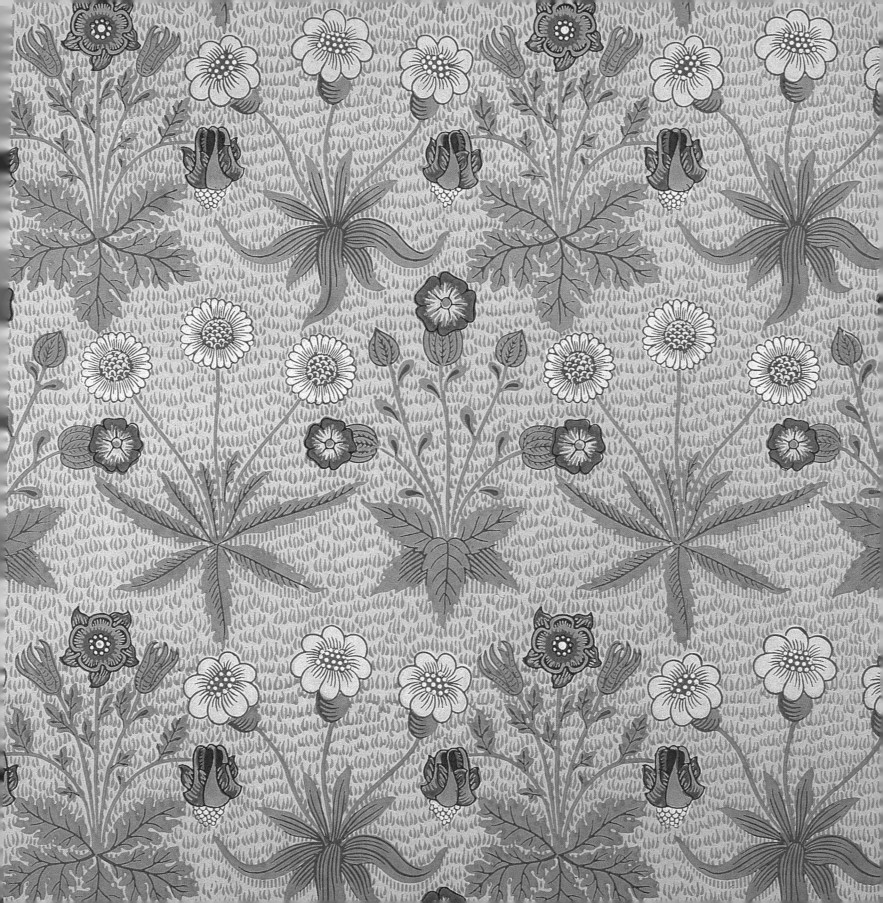

Fourth in the series is the well known English herbal by John Gerard, *The Herball, or Generall Historie of Plantes* first published in 1597 and revised by Thomas Johnson in 1633. Mackail says that Gerard was a favourite of Morris's childhood and that among the books at Woodford Hall was a copy which Morris studied eagerly. In particular he was interested in the 'beautiful drawings, many of which later gave suggestions for his own designs in the flower work of his earlier wall-papers, and in the backgrounds of designs for glass and tapestry'.

65. **Left** *Gerard's 1597 herbal open at a page describing the fritillary.*

May Morris recalled how her father would show his herbals to the two girls and John Gerard became their favourite too. 'We learnt to know old Gerard well', she said, and 'gentle gossip from London of the sixteenth century was pleasant reading'. Gerard's herbal, a best seller in its time, has been described as 'quaint'. It has never been regarded by botanists as a serious reference book and, despite Morris's admiration, the illustrations are not particularly accurate. They were mainly derived from blocks from the herbal by Tabernaemontanus, Brunfels's pupil.

As a good Londoner it is a very fair assumption that Morris would have also known of William Curtis's great work the *Flora Londonensis*, which shows all the known flora of London and was published in parts between 1775 and 1798. Ruskin, in his writings, spoke highly of the wood engravings in this book. Morris

66. **Right** *Design for **Wey** by William Morris, 1883 (Birmingham Museums and Art Gallery). This was one of the 'River' series and was printed on velveteen and cottons at the Merton works. The flower elements are not identifiable but perhaps a small sunflower motif has been incorporated.*

would certainly not have missed the significance of the engraved drawings which were often by William Kilburn, who, in the late eighteenth century, worked as a calico print and wallpaper designer (see page 76).

There are very few indications of the influence of the herbals in Morris's writings but Peter Cormack of the William Morris Gallery has noticed that 'Gerard' is marked on the floral areas of some Morris window designs and May Morris attributed the *Willow* design to Gerard. In a letter to Thomas Wardle, August 1875, Morris said, 'looking for a Gerard for you'. On the 23 November 1875 he noted, 'I have found a Gerard for you at last'. In another to Thomas Wardle, 8 January 1876 he wrote,

There are many editions of Matthiolus: some there are that have the cuts [woodcuts] *without the letter press* [text]: *pretty little books long in shape & very useful: I have the whole book a fine edition printed in Venice by Peter Valgrisius in about 1590; the cuts very big: certainly one of the best herbals: and the very beautiful herbal is Fuchsias de Stirpibus* [Fuchs], *a Basle book printed about 1530: I have a poor copy of it which I have found very useful: it is a rare book; but for refinement of drawing it is the best of all, as one would expect from the date.*

The source book for many of Morris's fabric dyeing experiments was Jean Hellot's *L'Art de la Teinture des Laines* published in 1750. Hellot was the inspector of the French royal dyeworks. Morris also had other dyeing books by Pierre Joseph Macquer and Homassel. In a letter to Wardle, Morris describes hunting for old dyeing books in Paris. Again to Wardle on 13 April 1876 he wrote,

When you write next will you tell me what I owe you for Rossetti's dyeing book – I find the book tough to translate and I suspect the receipts [recipes?] *are very shady but it is amusing. I have made enquiries for that 1605 English book.*

The Rossetti book was the *Plicto of Gioventura Rossetti* – the first known printed book on dyeing published in 1448. Morris's copy was dated 1540.

John Ruskin, who had such an influence on Morris, is also known to have had a deep interest in herbals. In 1874 during one of his many forays in Venice Ruskin discovered a little known manuscript herbal written in Padua by Jacopo Fillipi for the Lord of Padua around 1390, with illustrations added later in 1419. Many of the illustrations were original unlike the copies made for other herbals. Padua was the centre for medicine and the manuscript passed into the possession of Padua's botanic garden. Today the herbal is in the Marciana Library in Venice and it was there that it was discovered by Ruskin. The book

67. Right *Pimpernel wallpaper by William Morris, 1876. This design was thought to be a suitable wallcovering for 'rooms of dignified proportion'. It was used in the dining room of Kelmscott House. This pattern usually features a blue flower, although oddly there are only two really red wild flowers, the tiny scarlet pimpernel and the common field poppy.*

contains nearly 500 botanic illustrations of extremely high quality and Ruskin was so impressed that he employed a local artist called Antonio Caldar to make faithful copies of all the illustrations. Only a small amount of text was included in this copy which is now kept at Whitelands College, one of Ruskin's sponsored girls schools. Whether Ruskin ever showed the herbal to Morris is not known.

From his writings and designs one can see how Morris was deeply affected by flowers and plants. But although his knowledge of flowers was considerable, his designs are seldom botanically correct. Of the nearly 600 designs attributed to him by Mackail (this number is open to interpretation) there are very few, if any, that do not feature flowers, leaves, trees or plants. In some designs, animals or people are prominent, but usually these were contributions by other designers such as Philip Webb, Henry Dearle or Edward Burne-Jones. May Morris stated her father designed forty-five wallpapers and six ceiling papers. In addition there were many fabric, tapestry and embroidery designs. His design output was both prodigious, original and exciting.

After Morris had produced his first three designs in 1864 there was a break of about four years until 1868 when he designed five more papers and a chintz. Then another gap until 1871 when he began his most prolific designing period which lasted until around the end 1890. This was also the time when he was very involved in political activities and preparing to embark on his last venture with the Kelmscott Press. Because of this, after 1880 most designs were not Morris's but those of Henry Dearle, May Morris, Kate Faulkner or others. Morris and Company continued until 1940 to design, manufacture and market a wide range of floral based products, including carpets, rugs, wallpapers, fabrics, and embroideries. For a contemporary and personal description of Morris's designs one can do no better than read May Morris's account of her father's designs in her book *William Morris – artist, writer, socialist.*

69. Below *An engraving in Gerard's herbal captioned 'Tulipa narbonensis, French tulipa'.*

Most nineteenth-century designers were single-minded, commercial and professional, as indeed Morris often had to be to earn his living, to maintain his firm's competitiveness and thereby to secure his employees' livelihood. But more than this, and uppermost in his mind, he knew there was more to life than admiring nature, designing and writing. He knew people's lives should, and could, be better than they were and his intention was to encourage and develop this improvement one way or another.

68. Left *Wild Tulip wallpaper by William Morris, 1884. This design conjures up Morris's thought of the designs from Turkey and Persia and the Islamic influence on the flowers he studied in the South Kensington Museum. May Morris felt the design showed 'nature's profusion' The tulip has always had a fascination for flower painters and never more so than for the seventeenth-century Dutch and Flemish flower painters. To Morris and his friend William de Morgan the tulip was always the near eastern flower that had somehow made its way into gardens like Kelmscott. Again May says the wild tulip was one of the richest blossomings of the spring garden there.*

70. Right *Woodblock for Tulip. Wood block printing was used for both wallpapers and fabrics. It is a slow, skilled method of manufacture but was preferred by Morris to the more productive but limited roller printing process. Many blocks, usually made from pearwood, are required for printing a single design. The Acanthus wallpaper, for example, uses sixteen blocks, while Daisy requires twelve.*

He was an example of his own professed principles. All his life, as has been illustrated in this book, he studied, admired and applied nature to improve his life and his work and to create good examples for others, whether with a story, a poem, a wallpaper, a book or a speech. What is more important he always seemed to try to do his best – to be a man of quality. His historical knowledge was extensive and deep, and Morris the poet, and writer of romantic prose, had the imagination that other designers lacked.

Morris himself summarised the key qualities for a designer when he said you must fully understand nature and study it closely, know your history and then develop and use your imagination. A message for everyone, perhaps, not simply rules for pattern designers.

It can be thought that to write separately about Morris's poetry, Morris's socialism, his wallpapers and chintzes, his gardens and flowers, how he did calligraphy and so on could be to miss the essential Morris. Morris's energy and application in all things was indivisible – all facets are part of the whole man

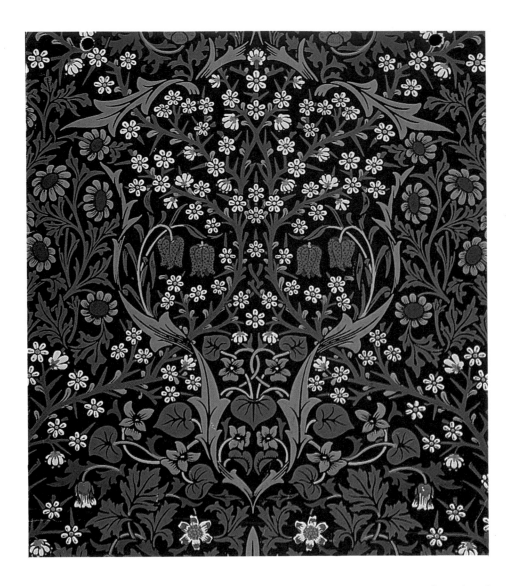

71. Left *Blackthorn* on printed cotton by William Morris, 1892. This was one of Morris's last and most popular designs. It was completed at a time when he was very involved in politics and book production. The design contains many varieties of flowers including the fritillary, hawthorn or blackthorn, daisy and violet. It is a fabric which, if unlined and with the sun behind it, lights up like fairy lights.

and it is the whole man that is important. As Frederick Ellis, Morris's friend and publisher, said in 1898,

> *Those who knew him best will bear me out when I say never was there any man more entirely free from conceit and self consequence. Though fully conscious of his own power and inherent ability, he was looked up to by his fellows as a man of genius. He was nevertheless one of the most simple minded, yea, one of the most humble minded among men. His consciousness of power and knowledge in such things as he gave his mind to, raised him above petty conceit; while his clear conception of the limitations of his own, and of all human knowledge, engendered in him that humility which is a special note of truly great minds.*

INDEX

Photographic acknowledgements

The author and publisher are grateful
for permission to reproduce from all
those who have supplied photo-
graphs for the illustrations. Where the
source is not clear from the caption
photographs have been supplied as
follows:
Bridgeman Art Library 35
British Library 7, 45
Martin Charles 33
Fitzwilliam Museum, Cambridge 48
London Borough of Waltham Forest
Archives 10, 14
National Trust 39
Private Collection 3, 22, 32, 40,
44, 50, 64, 67, 68, 70, 71, endpapers
and jacket
RCHME © Crown Copyright 41
Royal Horticultural Scociety, Lindley
Library 65
Kay Sanecki 17
Scala 28, 29
Society of Antiquaries of London
1, 43
Stapleton Collection 40
Victoria and Albert Museum 52, 58
William Morris Gallery, Walthamstow,
London 5, 6, 9, 30, 36, 42